General Editor
David Piper

EL GRECO
Every Painting

Introduction by Ellis Waterhouse
Barber Professor of Fine Arts, Birmingham University, 1952–70

Catalogue by Edi Baccheschi
translated by Jane Carroll

RIZZOLI
NEW YORK

Foreword by the General Editor

Several factors have made possible the phenomenal surge of interest in art in the twentieth century: notably the growth of museums, the increase of leisure, the speed and relative ease of modern travel, and not least the extraordinary expansion and refinement of techniques of reproduction of works of art, from the ubiquitous colour postcards, cheap popular books of colour plates, to film and television. A basic need – for the general art public, as for specialized students, academic libraries, the art trade – is for accessible, reliable, comprehensive accounts of the works of the individual great masters of painting; this has not been met since the demise before 1939 of the famous German series, *Klassiker der Kunst*; when such accounts do appear, in the shape of full *catalogues raisonnés*, they are vast in price as in size, and beyond the reach of most individual pockets and the capacity of most private bookshelves.

The aim of the present series is to provide an up-to-date equivalent of the *Klassiker* for the now enormously enlarged public interested in art. Each volume (or volumes, where the quantity of work to be reproduced cannot be contained in a single one) catalogues and illustrates chronologically the complete paintings of the artist concerned. The catalogues reflect as far as possible a consensus of current expert opinion about the status of each picture; in the nature of things, consensus has yet to be reached on many points, and no one professionally involved in the study of art-history would ever be so rash as to claim definitiveness. Within the bounds of human fallibility, however, every effort has been made to achieve both comprehensiveness and factual accuracy, while the quality of reproduction aimed at is the highest possible in this price range, and includes, of course, colour. Every effort has also been made to hold the price down to the lowest possible level, so that these volumes may stay within the reach not only of libraries, but of the individual student and lover of great painting, so that they may gradually accumulate their own 'Museum without Walls'. The introductions, written by acknowledged authorities, summarize the life and works of the artists, while the illustrations place in perspective the complete story of the development of each painter's genius through his career.

David Piper

Introduction

Knowledge about El Greco's life (1541–1614) derives chiefly from many documents which survive from the last thirty-seven years of his life, which he spent at Toledo. In one of these he says that he was 'a native of the city of Candia', and in another, of 1606, that he was then sixty-five years old. He gives the impression of being a truthful man and likely to be reliable about facts, so that we can accept that he was born in 1541 in Crete, in the city now known as Iraklion. Like all Cretans he was proud of his origins, and, up to the end of his life, he signed his pictures with his name in full, in Greek letters, adding the word 'kres' (= the Cretan) on the more important ones. His full name was Domenikos Theotokopoulos, but as this was obviously too much of a mouthful for those who were not Greek, it is not surprising that Giulio Mancini, giving an account of his Roman years, mentions him as '. . ., commonly known as il Greco'. The curious hybrid form, El Greco, with the Spanish article and the Italian 'Greco', has become standard and gives something of the flavour of his sophisticated personality.

It seems to me certain (although modern Greek scholars question it) that Greco was brought up as a Catholic and was always profoundly concerned with the correct representation of Catholic dogma. Among the books in his extensive library was a copy of a Greek translation of the proceedings of the Council of Trent: and his library list also reveals that he must have had a good humanist education. But recently published documents indicate that he probably spent the first twenty-five years of his life in Crete and that in 1566 he was an established painter at Iraklion and had painted a picture of the Passion, which was described as '*dorato*' (i.e. presumably painted on a gold ground in the local icon tradition): and also that he had gone to Venice by 1568. These documents also reveal that in 1567 there was in existence a Guild of Painters (*Scuola de' Pittori*) at Candia: and they make it seem possible (perhaps even likely) that the Modena triptych (Nos. 3A–F) which is in an icon technique and signed '*cheir Domenikou*' (= hand of Domenikos) may

really be by Greco. This form of signature also occurs on two unquestionable early Spanish Grecos (Nos. 17a and 20a) but it does not necessarily carry with it all other pictures in an icon-like technique which have the same signature, which is a formula common to icon painters, and there may well be several such who can only be given the name of 'Master Domenikos'. At any rate it seems clear that, as soon as he had reached Venice, Greco was at great pains to abandon this icon tradition and to adopt a technique which derives entirely from the painters of the Venetian High Renaissance.

The Dalmatian miniature painter and illuminator of manuscripts, Giulio Clovio (1498–1578), in a letter of November 1570 to his patron in Rome, Cardinal Alessandro Farnese, mentions 'a young Candiot, pupil of Titian' (even Clovio found Greco's real name impossible!) 'who in my judgement is exceptional in painting'. There can be no doubt that this was Greco, and the letter secured for him accommodation in the Farnese Palace in Rome and introduction to its scholarly Librarian, Fulvio Orsini, whose inventory (1600) lists several paintings by 'il Greco'. Since Alessandro Farnese had been painted by Titian it is unlikely that Clovio would have made the statement that Greco had been a pupil of Titian if it were not true. But it must be admitted that Greco's work at no time shows much influence from Titian's paintings of these last years of his life. It does, however, establish that Greco must have spent the years since he left Crete about 1566 in adapting himself to a western, and specifically Venetian, style of painting. The proof of this lies in the signed *Portrait of Clovio* (No. 11), painted soon after 1570, which is now among the Farnese pictures at Naples. In this no traces survive of the icon tradition and scholars have rightly seen in this, and in a companion Greco at Naples of a *Boy lighting a Candle* (No. 15b) a considerable influence of Jacopo Bassano. There are still traces of that icon technique in the earliest version of the *Purging of the Temple* (No. 8a), which must date from before 1570, and reveals a powerful influence from Veronese and also some

3

knowledge of Tintoretto. This shows that during the years in Venice, from *c.* 1566 to 1570, Greco was deliberately absorbing everything he could from all the great Venetian masters.

The subject of the *Purging of the Temple* probably has reference to the Council of Trent (which had been concluded in 1563). It was to fascinate Greco throughout his life – at least seven more or less original versions are known – and in one picture, dating from his Roman years (No. 8b), he makes clear what new influences he absorbed in Rome. On a separate piece of canvas, added as an afterthought, he has placed portraits of Titian, Michelangelo, Clovio and Raphael. It is not altogether clear whether this is a more or less modest testimony of indebtedness, or whether it may not have been added, when he took the picture to Spain, as an arrogant statement that his work was as good as that of these eminent masters. For there is ample evidence that the later Greco did not underestimate his own merits. Clovio's influence on Greco might be supposed to be limited to having furthered his career, but he may have been inserted as a chief source for Greco's knowledge of Mannerism – and at that time, however dim his reputation may be today, Clovio was regarded as a great master.

Between the end of 1570, when he arrived in Rome, and the end of 1576, which is the probable date of his migration to Spain, we know very little about Greco. Giulio Mancini, writing a few years after Greco's death, but certainly with some contact, at any rate at second hand, with those who remembered him in Rome, suggests that Greco's works impressed contemporaries favourably, but that he had to leave Rome for Spain because he had made himself so unpopular with the painters of Rome by saying, when Michelangelo's *Last Judgement* was under post-Tridentine attack for its excessive nakedness, that 'if the whole work was scrapped he would have done [the subject] himself with *honestà et decenza* and not inferior [to Michelangelo's] in quality of painting'. The story may not be true, but it sounds like Greco – and in 1611 he said to Pacheco that 'Michelangelo was a good man, but didn't know how to paint'. It is possible that the *Allegory of the Holy League* (No. 32b), which

incorporates a Last Judgement, may be Greco's idea of the sort of post-Tridentine way in which he would have liked to replace Michelangelo's fresco.

The leading painters in Rome during these years were Federico Zuccaro (who was abroad or in Florence from 1574), and Lorenzo Sabatini (d. 1577), who was in charge of the most important surviving decorations in the Vatican during these years, the ceiling paintings in the Loggie of Gregory XIII. From these he could have learned the vocabulary of Roman Mannerism, but the technical qualities which Greco displayed as soon as he had reached Spain suggest that he had rather continued his studies in the Venetian tradition and he may well have had access to the group of pictures by Titian in the Farnese collections.

As far as we know El Greco received no important commission during his Italian years, nor had he painted any picture which gave promise of his becoming a great master when he left for Spain at the age of about thirty-five. Competition at that time was intense in Rome, and it was even more formidable in Venice. It was known that in Spain there was a demand for Italian painters and that Philip II, Titian's most lavish patron, had great plans for the decoration of the new palace and monastery of El Escorial which he had begun to build in 1562. In Rome Greco had contact with certain Spanish scholars, notably Don Luis de Castilla, who was to become a life-long friend at Toledo. Don Luis's brother, Don Diego de Castilla, was dean of Toledo Cathedral and a central figure in all Toledan patronage. He was to give Greco his first commissions in 1577 and work was probably at least half promised before Greco left for Spain. He certainly went with good introductions, so that he could make himself known at the Spanish court. It is a reasonable guess that he took with him the small version of the *Allegory of the Holy League* (No. 32b), in which Philip II is the most conspicuous figure, a remarkable invention combining Counter-Reformation religious and political ideas, which he could have invented as a replacement for Michelangelo's *Last Judgement*! At any rate Philip II commissioned a larger version of this composition within a year or so of Greco's

arrival in Spain. But the first commission Greco received was in 1577 for eight paintings (three of them full altarpiece size) for the newly built nuns' church of Santo Domingo el Antiguo at Toledo. This was an act of astonishing boldness (or prescience) on the part of Don Diego de Castilla, who was in charge.

Also in 1577 Greco received the commission for the picture of the 'Disrobing of Christ' (*Espolio*: No. 22a) for the altar in the Vestiary of Toledo Cathedral. This must also have been due to Don Diego de Castilla, as also presumably was the order for a *St Sebastian* (No. 24) for Palencia Cathedral, where Castilla had been archdeacon. These ten pictures are the masterpieces of Greco's first Spanish style and established his reputation in Spain. They are brilliantly and powerfully painted, with sweeping strokes of the brush, in a Venetian technique, and they display a mastery of execution which our knowledge of his Italian works would not have led us to expect. Serious and profitable study of Michelangelo (especially in the *St Sebastian*) and of Tintoretto and early Titian is apparent, and the narrative content, in realistic and human terms, is trenchantly expressed. It was not until later, in the middle 1580s, that Greco was to turn to representing the visionary and the transcendental.

It is clear that the sophisticated and reformist religious climate of Toledo during the last quarter of the sixteenth century constituted an *ambiente* which fostered and brought to flower Greco's natural gifts as an interpreter of religious themes in the spirit of the Counter-Reformation. Greco's main painting career coincides precisely with that period between the conclusion of the Council of Trent in 1563 and the death of Clement VIII in 1605, when deeply religious painters had a chance of creating their own personal formulae for the interpretation of post-Tridentine religious ideas. By about 1610 the church had decided to take over the official direction of the iconography of the Counter-Reformation. Three great painters made memorable contributions to religious art during these years – Baroccio, El Greco, and Caravaggio. After they died the church more or less disavowed their solutions when it took over the direction of religious art, and this

has made El Greco in particular seem a more isolated figure than he really was.

The most spectacular of these early Spanish Grecos – and still among the most arresting and life-enhancing scenes from the Passion of Christ – is the *Espolio*. Although not unknown in the Middle Ages, it was practically an unknown subject in the sixteenth century and there was no canonical way of representing it. Though now over the main altar in the Sacristy, it was designed for the altar in the Vestiary (which in Toledo Cathedral is still one of the richest in the world), for which the scene is wonderfully appropriate. Dispute over treatment and dispute over price followed its unveiling and litigation of the latter sort was an almost constant tribulation with many of Greco's major commissions – which was not always helped by Greco's view that his pictures were always worth far more than it would be possible to pay! There were no native painters of any distinction in Toledo, but such painters as there were could always be called in by cheese-paring ecclesiastics to undervalue the work of an envied 'foreigner'. The dispute over the treatment – whether it was proper for the Marys to be present at the scene and whether it was not improper that the heads of some of the crowd should be shown higher than Christ's head – was more serious, since the Inquisition could be involved. What is astonishing is that, although Greco promised to make alterations, he did nothing of the sort. It is likely that the Archbishop and the Dean were on his side. It is usually said that there are Byzantine precedents for the scene and that this shows the beginnings of a return by Greco to his Byzantine sources. But this does not seem to me to be true. The power of light which radiates from Christ's crimson robe is in a Venetian and not a Byzantine tradition.

The reputation achieved by these first altarpieces caused Philip II to commission in 1580 a large altarpiece, the *Martyrdom of St Maurice* (No. 36), for the Escorial. This was completed in 1582 and was a conscious exercise in a new style which employed certain compositional resources of the fashionable Roman Mannerism but is much more lucidly expressive of its narrative content and more emotionally charged with religious feeling

than was customary with Mannerism. The main scene of martyrdom takes place in the background at the left, illumined by heavenly rays, while the foreground at the right is occupied by a close-up with life size figures of St Maurice and his commanders, in a group which owes a good deal to Raphael's *Stanze*, discussing with Spanish gravity the necessity for the martyrdom. It is an intensely moving picture, executed with a breathtaking virtuosity: and the foreground still life was no doubt intended to gratify the taste, shared by all royal persons, for photographic realism. But Greco had miscalculated the royal taste; Philip II disliked the picture and replaced it at once by a picture by a tame Italian.

The way of royal patronage being thus closed, Greco fell back on Toledo, where he organized a considerable studio, on Venetian lines, and from about 1580 until his death there in 1614, he had a virtual monopoly of all important commissions in the diocese. In 1611 Francesco Pacheco, the father-in-law of Velazquez and the artistic watchdog of the Inquisition, visited Greco, who may have been a little mischievous in talking to this self-conscious representative of a generation with which he hadn't much sympathy. Pacheco relates that Greco showed him 'the originals of all the pictures he had ever painted in his life, painted in oil on very small canvases'. This was no doubt an exaggeration and what Pacheco saw was the series of small versions of all the designs Greco had produced since opening his studio about 1580. These small paintings, many of which are listed in Greco's *post mortem* inventory, have largely disappeared (though Nos. 94a and 94c may be examples): but their purpose seems to have been so that the studio could turn out replicas, varied in size and proportions, to order. It has been shown that Greco artfully arranged that the positions of the figures in his compositions bore exact functional relations to the height and breadth of the canvas, so that, with a knowledge of these principles, studio assistants could lay out any Greco design on canvases of other sizes according to the requirements of the commission.

Of certain popular St Francis designs there are an astonishing number of versions and there is no doubt that a great many of these are studio or school copies – although it used to be supposed that they were all originals, since it was not imagined that a painter as individual as Greco was thought to be could have had a busy studio, operating almost like a factory. Greco's studio was in the Venetian tradition and turned out a great many pictures – some of them 'signed' so as to provide a guarantee of origin – in precisely the same way as the studio of Giovanni Bellini. But the brilliance of his autograph execution remained constant until the end of his life, and the way his studio operated was perfectly well known, since the contract for one of his last major works (No. 142A), commissioned in 1607, stipulates that the picture 'should be executed with his own hand and not by another'.

The style of the St Maurice was not repeated. It had been a miscalculation (though a splendid one) intended to appeal to the King's taste. It was not what Greco adopted for 'home' consumption at Toledo. His later Spanish style reached maturity in *The Burial of the Count of Orgaz* (No. 47), an enormous painting – the largest in Toledo – over fifteen feet high, which Greco painted for the church of Santo Tomé. It has always been justly considered his quintessential achievement, and it was also a sort of programmatic manifesto of his own varied powers, to show off the sort of works he was prepared to do.

The Count of Orgaz had died in 1323, but it was only on the conclusion of several centuries of litigation that the church of Santo Tomé was able to benefit from the generous intentions of his will. A legend related that St Stephen and St Augustine had miraculously assisted at his burial and it is this story which is the subject-matter of the picture. The Council of Trent had decreed that 'no unusual image, unless it had been approved by the bishop' was to be placed in any church, and *The Burial of the Count of Orgaz* was a very unusual image. The Archbishop of Toledo gave permission for it to be painted in 1584, but the contract with Greco was not signed until 1586 – which suggests that the Archbishop only approved the subject and had not actually approved the *modello* for the picture, which must have been worked out jointly by Greco and the parish priest, who figures prominently in the scene.

It is convenient to quote what I wrote in

1972: 'The upper part displayed Greco's style for religious mysteries, in which the human figure takes on a more elongated form and a repertory of majestic gestures against a world of clouds: the wonderful row of portraits below, which presumably includes most of the intellectual "establishment" of Toledo on whom Greco relied for his patronage, showed how he could treat figures of this world with that combination of naturalism and high gravity which the Spanish nobleman required: and the "historical" scene in the foreground shows an ennobled half-realistic narrative treatment of a very high order. The vestments of the saints are embroidered with examples of Greco's vein in figures of single saints, or, as in *The Stoning of St Stephen*, of religious histories.' The scene in heaven, in which an angel is conveying the tiny soul of the Count to the company of the saints, is also a deliberate exposition, as if against unbelievers, of the Catholic doctrine – much impugned by the Reformed churches – of the importance of the intercession of the Virgin and the saints for the salvation of the individual. The whole picture is also a perfect demonstration of a central characteristic of Spanish religious painting during the 'great century', that there is a continuity between the world of appearances and the world of vision. This Cretan foreigner has become a quintessentially Spanish artist; it is clear why Greco's friend Fray Hortensio Félix Paravicino began the sonnet on his tomb: 'Creta le dió la vida, y los pinceles Toledo' (Crete gave him life, but Toledo gave him his art). In the technique of the heavenly portion of the picture there is also a procedure which was now standard with Greco, and which he was to use increasingly – the warm bolus ground (on which all his Spanish pictures are painted) is allowed to show through the paint for the shadows.

The *Burial of the Count of Orgaz* also provides the best evidence to counter the foolish ideas, which have often been expressed, that Greco's elongation or 'distortion' of the human figure is the result of astigmatism or of some optical defect. The row of mourners, who are certainly portraits of Greco's contemporaries (and one or two of whom can be identified) and are painted with astonishing precision of likeness as well as

with the profoundest psychological penetration, makes it clear that Greco had perfectly normal vision. It was in fact only in the field of portraiture that Greco had shown something like his real powers before he left Italy—as is demonstrated by the portrait of Giovanni Battista Porta (No. 12), which was considered to be a Self-Portrait by Tintoretto from at least 1760 until the signature was noticed in 1898. In the *Lady with a Fur* (No. 25) which I accept as the portrait of the lady, Doña Jerónima de las Cuevas, who lived in what appears to have been honourable concubinage with El Greco at Toledo, and which seems to have been painted about the time he first met her in 1577, we have what is perhaps the first 'modern' portrait of a beloved woman.

After Titian's death in 1576 Greco had claims to be the finest portrait painter in Europe and the very few portraits he painted in his later years have no rivals until Rubens. Even the best of Tintoretto's very uneven portrait output is inferior. The *Cardinal Niño de Guevara* (No. 97a), painted about the time the sitter was appointed Inquisitor in 1600, certainly owes something, in its interpretation of an uneasy churchman's mind, to Titian's portraits of the Farnese Pope; but the astonishing portrait, called rather unconvincingly *Canon Bosio* (No. 124), surpasses in penetration and vitality Titian's later portraits. Nor is it surprising that it was John Sargent who persuaded the Boston Museum to buy the *Fray Hortensio Félix Paravicino* (No. 138), which achieves to perfection qualities at which Sargent was to aim in his best portraits some three hundred years later.

The lower half of the *Burial of the Count of Orgaz* is one of the last examples of Greco's more or less naturalistic and descriptive style. After the mid-1580s, except for his infrequent portraits, Greco concentrated on his later conceptual and expressive style in which the world of vision replaces the world of appearances. He was no longer called upon to represent anything but religious subject-matter treated in the spirit of the Counter-Reformation. The illustration of these religious truths was at the heart of Greco's artistic interest, and it is this which gives his inventions their power to impress even a world which has very different notions about

religious truth. He was perfectly at home in the obsessively religious city of Toledo, which was also the scene in these years of the religious meditations of St Teresa and St John of the Cross. Toledo had ceased to be the political capital of Castile in 1561, when Philip II had decreed that Madrid was to be the *unica corte*, but it remained the religious capital. The atmosphere is sufficiently conveyed by a writer in 1617 who says of Toledo that 'there was so much listening to masses and to sermons that it was as if Holy Week were prolonged for the whole year'.

In his pursuit of the visionary El Greco gave up the use of human models and took to using little models of wax, plaster or clay which he could suspend or dispose as he pleased, and whose forms were no doubt elongated in accordance with his own ideas about the inhabitants of his visionary world. He may have derived the use of little wax models from Tintoretto, but it is reasonable to suppose that the elongation of their figures owes a good deal to his Byzantine upbringing and is a reversion to an element that he now found valuable in a style which he had been at such pains to forget. Modern Greek writers, in seeking to claim Greco as a 'Greek' rather than a Spanish artist, have given rise to the most exaggerated claims that many aspects of Greco's later style are legacies from his Creto-Byzantine heritage, but I am not convinced by any of their iconographic suggestions. However, there is no doubt that Byzantine art was essentially concerned with the visionary, and elongated the human figure for that end; that Greco was accustomed from childhood to this practice; and that it is reasonable to believe that he reverted to it in later life when he once again became preoccupied with conveying visionary and transcendental ideas. But this time it was wholly in the service of post-Tridentine Catholicism.

During the last twenty years of the sixteenth century Greco and his studio turned out a very great number of devotional paintings which depicted the new theme of saintly penitence, especially in figures of the Magdalene, St Peter, St Francis and St Dominic. These find a parallel in Italy in similar pictures by Baroccio, Cigoli and others which fulfilled a need for devotional paintings which were not altarpieces but found a place in the cells, parlours and corridors of monasteries or nunneries – and also no doubt in the oratories in the private houses of devout persons. Greco tried out a great variety of types, especially for St Francis: in addition to two separate designs for altarpieces (Nos. 114a and 118a) we know of rather more than fifty such pictures which have at least some connection with the studio. He would sometimes modify a particular design until he got it right, and then move on to another: and it is my impression that the studio did not keep two designs for the same theme going at the same time.

In a similar style to these El Greco and his studio, perhaps particularly after 1600, painted many pictures in series known as *Apostolados* – that is, twelve separate pictures of the Apostles usually accompanied by a thirteenth of Christ blessing. The finest of the surviving sets, the one in the Sacristy of Toledo Cathedral (Nos. 116A–M) may well still be hanging in the arrangement for which it was intended, with six pictures, marking the bays, down each of the long side walls. The colours in which each of the Apostles is dressed seem to be canonical, but a good deal of freedom of choice was left to the artist in selecting his types, and it is a considerable feat of the creative imagination to invent twelve different ideal types of men imbued with the Holy Spirit.

A considerable number of commissioned works survive from 1591 onwards, so that it is possible to study clearly Greco's development during his last years. In 1591–2 the studio turned out three pictures (Nos. 64A–C) for the small village church of Talavera la Vieja. What is remarkable about them is that, although they are rather battered today, they must always have been extremely feeble. They were no doubt cheap and Greco did not bother to execute anything with his own hand. But precisely the opposite was true of the *retablo* commissioned in 1596 for the Augustinian church, dedicated to the Annunciation, of the Colegio de Doña Maria de Aragón at Madrid (Nos. 94A, B and C) which was completed by 1600. This was a vast work, whose architecture, sculpture and paintings were all commissioned from Greco. We have insufficient information about it, but it seems certain that at least the principal paintings

were the three altarpiece-size pictures, the *Annunciation* (in the Museum at Villanueva y Geltrú) in the centre, and the *Adoration of the Shepherds* (Bucharest) and the Prado *Baptism* at the sides. These three great altarpieces, still in wonderfully pure condition, seem to have been executed entirely by Greco's own hand. They have a sparkling vitality and an exuberance of virtuoso brushwork which should have convinced the court at Madrid that there was a great master in Spain. But their execution coincided with the death (1598) of Philip II. It is with these pictures for the Colegio de Doña Maria de Aragón that the question first arises whether Greco should not be considered a Baroque artist. They are certainly not Mannerist.

During the same years, 1597 to 1599, Greco painted three other great altarpieces of equally sustained virtuosity of execution. These were for the tiny Carmelite Chapel of San José at Toledo where the high altar (No. 92B) survives *in situ*, while the two side altarpieces (Nos. 92C and D) are in Washington. The iconography here shows Greco as very much in the centre of the devotional life of Toledo. The chapel had been intended by its founder, Martín Ramírez, for St Teresa and her nuns, and it was dedicated to St Joseph, St Teresa's favourite saint. The high altar shows a tremendously elongated, youthful St Joseph – the head goes seven times into the whole figure – protecting the youthful Christ. It is one of the first important representations of this new devotion to St Joseph, which was to become a favourite Counter-Reformation theme, especially in Spain. The side altars, with St Martin and the Virgin and Child with St Martina and St Agnes, show the founder's patron saints. The chapel is so small and narrow that they seem to have been designed to look best (especially the St Martin) when seen slightly askew by the worshipper entering the chapel – an early Baroque refinement which is also found, at very nearly the same date (1600/1601) in Caravaggio's side paintings in the Cerasi chapel in Santa Maria del Popolo in Rome. It has been plausibly suggested that Rubens, on his visit to Spain in 1603, may have seen the *St Martin* and derived inspiration from it for his equestrian portrait of the Duke of Lerma (Prado), which marks an immense step forward in his development.

It is noteworthy that in the backgrounds of the two pictures for the San José chapel in which some indication of the earth rather than of the heavens is suggested, it takes the form of a rather hallucinatory view of Toledo, which seems to have become for Greco a sort of symbol for the City of God on earth. This attitude may hint at the significance of the *View of Toledo* (No. 106a), a picture which has long been famous as the only 'pure landscape' of the sixteenth century. It must have had some profounder significance than that. Since it is known at least latterly to have accompanied the portrait of Cardinal Niño de Guevara, painted when he was Inquisitor and Archbishop of Toledo, it may have originally accompanied that portrait in the Cardinal's funeral chapel. It is purely an accident that the Greco landscape, when hung (as it used to be in Mrs Havemeyer's house) with fine landscapes by Cézanne, seemed to belong to the same world of artistic creation.

The *Vision of St Ildefonso* at Illescas (No. 111E) was probably painted about 1602–3, and the satisfaction that it gave led to the commission for the general decoration of the sanctuary in the church of the Hospital of Charity at Illescas (Nos. 111A–D). This work, which included sculpture, was executed 1603–5 and the original setting has been completely destroyed although the paintings survive. It has been plausibly contended that the original scheme of decoration provides 'the first example of a Baroque chapel in Europe', in which the whole scheme was intended to be seen as a unity from a single viewpoint.

The latest documented commission which El Greco completed was for the Oballe Chapel in San Vicente (Nos. 142A and B) at which he was at work from 1607 to 1613, of which the *Immaculate Conception* remained *in situ* until 1961, though the *Visitation* seems never to have been placed on the ceiling in spite of being completed. These two pictures are the logical conclusion of Greco's devotional style and are among the most masterly illustrations of the world of vision. The composition of the *Immaculate Conception* is based on the movement of flames and the figures soar heavenwards with a dynamic vitality unequalled in western painting. Only Correggio's dome

fresco in Parma Cathedral, which Greco may have seen as a young man in Italy, can in any way compare with it. It is as complete an illustration of the full Baroque as Baciccia's ceiling of the nave of the Gesú in Rome of seventy years later.

The *Adoration of the Shepherds* (No. 151a) which Greco painted about 1612–14 for an altar intended for his own tomb chapel in Santo Domingo el Antiguo is a worthy companion to the San Vicente pictures: but the altarpieces on which he had been engaged since 1608 for the Hospital of St John the Baptist (Nos. 153A and B) were in too unsatisfactory a state to be left as they were, and El Greco's son, Jorge Manuel (1578–1631) took a hand in them and inevitably became involved in hopeless litigation. Only the surviving part of the *Opening of the Fifth Seal in the Book of Revelations* (No. 153C) seems to be Greco's unaided work and it remains problematical what the whole composition was like, but the figure of St John the Divine plays something like the role of the giant order in a Baroque façade.

Jorge Manuel is already documented as working in his father's studio at the time of the Illescas commission and his style owes everything to his father, but his executive powers were feeble and he did not have the faintest spark of that spiritual fire which informed his father's genius. A series of five large canvases painted in 1607–9 for the church of Titulcia (of which the most accessible is in the Museum of the Hispanic Society in New York) make it plain that his was not one of the hands responsible for the great bulk of the output from Greco's studio. The same is true of the one painter of any consequence known to have been (1603–7) in Greco's studio. This was Luis Tristan (d.1624), whose signed works show no real sympathy with, nor understanding of, Greco's style.

One other quite exceptional late work remains to be mentioned, the *Laocoön* (No. 145), whose subject matter might at first seem alien to everything El Greco had painted during his later years. It is obviously a haunting cry of anguish concerning Toledo but had remained a mystery until David Davies provided a convincing explanation. Bartolomé Carranza, Archbishop of Toledo,

had died in 1576 after eighteen years imprisonment by the Inquisition because his advocacy of spiritual reform led to an accusation of Erasmian tendencies. His supporters in Toledo included Greco's chief patron, Don Diego de Castilla, and no doubt others of his particular friends. The view of Troy in the background is a view of Toledo—which had been traditionally founded by refugees from Troy. Laocoön, the high priest was devoured by serpents (symbols of Heresy) for denouncing the wooden horse, which was to prove fatal to Troy—and the wooden horse had been used as a metaphor for the sale of benefices which Carranza had denounced. This huge picture is in fact a religious parable, easily understood by those for whom it was intended, of the desperate position at Toledo of those religious reformers with whom Greco was aligned. Their eclipse, about the time of Greco's death, helps to account for the fact that his works, which had satisfied so well the devotional aspirations of his own generation, fell out of favour, and almost out of memory until the nineteenth century, when the pillage of Spain by the French during the Peninsular War caused many pictures by Greco to be seen for the first time out of Spain, and especially in Paris.

It was painters like Degas and Millet who owned pictures by Greco and were the first to draw attention to his virtues as a painter rather than as an interpreter of religious beliefs. Manuel B. Cossio, in a most memorable book published in 1908, was the first not only to attempt a full catalogue of El Greco's work, but to give back to him in Spain the intellectual and artistic stature which he deserved. Since then the literature on El Greco has perhaps been excessive – and a good deal of it very silly. The first to make the heroic attempt to sort out Greco's own works from those painted in whole or part by the studio – not to mention the increasing number of modern forgeries – was Professor Harold E. Wethey, whose two volumes, *El Greco and his School*, Princeton, 1962 (revised Spanish edition, Madrid 1967) remain much the most valuable catalogue of the very extensive output of the master and his pupils.

Ellis Waterhouse

Catalogue of the Paintings

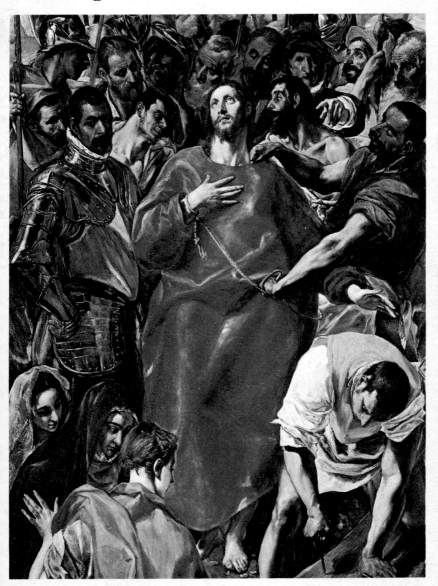

The catalogue lists the authentic works and also the most reliable of the attributions. Where there are several versions of the same theme, these have been grouped together under the same catalogue number but distinguished by small letters, e.g. 1a, 1b, 1c, etc. The individual parts of a composite work are listed with capital letters under the relevant catalogue number (1A, 1B, 1C, etc). An asterisk before the date of a painting means that it might have been painted earlier; after the date means that it might have been painted later; before *and* after means of course that it might be earlier or later.
All measurements are in centimetres.
s. = signed

1 The Adoration of the Magi
Mixed technique (oil-tempera) on canvas on panel/ 40 × 45/1561–2
Athens, Benaki Museum
Attribution

2 The Last Supper
Panel/43 × 51/*1565*
Bologna, Pinacoteca Nazionale
Attribution

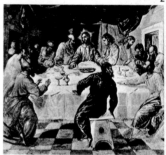

The Disrobing of Christ (El Espolio) (No. 22a). (p. 11)
This is one of El Greco's earliest masterpieces, painted for Toledo Cathedral. Its theme is the episode from the Scriptures in which Christ is disrobed before being crucified.

Lady with a Fur (No. 25).
The subject of this portrait is traditionally identified as Jerónima de las Cuevas, lifelong companion of El Greco from his early years in Toledo and mother of his son Jorge Manuel.

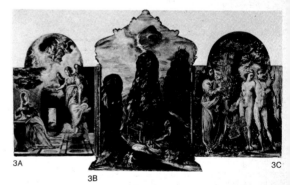

1

2

3A 3B 3C

3D 3E 3F

12

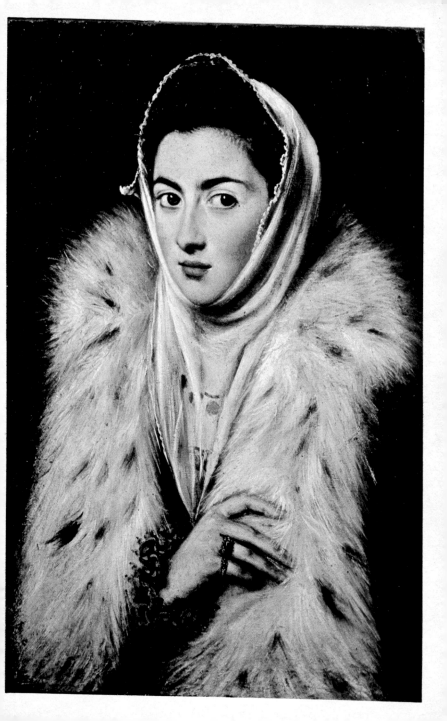

MODENA TRIPTYCH
(Modena, Galleria Estense)

3A The Annunciation
Tempera on panel/24 × 18/
1567

3B View of Mount Sinai
Tempera on panel/37 × 23.8/
s./*1567*

3C Adam and Eve with their Creator
Tempera on panel/24 × 18/
1567

3D The Adoration of the Shepherds
Tempera on panel/Back of
No. 3C

3E Allegory of a Christian Knight
Tempera on panel/Back of
No. 3B

3F The Baptism of Christ
Tempera on panel/Back of
No. 3A

4a The Adoration of the Shepherds
Tempera on panel/63 × 76/
1570
Frederikssund (Denmark),
Willumsen Museum
Attribution

4b idem
Panel/77 × 64/1570
Milan, Bonomi Collection
Version of No. 4a with
variations
Attribution

4c idem
Oil on canvas/114 × 104/
1570–2
Kettering
(Northamptonshire),
Buccleuch Collection
Version of No. 4a with
variations

5 St Francis receiving the Stigmata
Tempera on panel/29 × 20/s./
*1570
Naples, Capodimonte

6 The Adoration of the Magi
Mixed technique on panel/
45 × 52/s./*1570
Madrid, Museo Lázaro
Galdiano

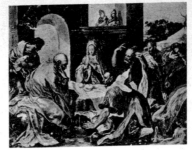
4a

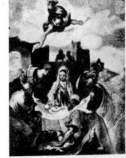
4b

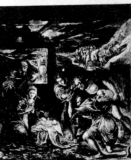

5

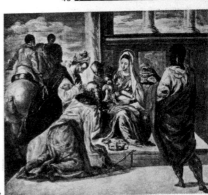
4c

6

14

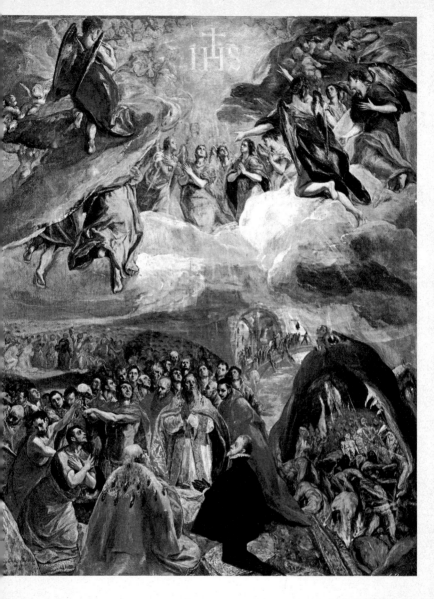

Allegory of the Holy League (No. 32a)
A symbolic work representing the Holy League's victory over the Turks at Lepanto in 1571. In the foreground are the leaders of the Holy League, Pope Pius V, King Philip II and the Doge of Venice, Alvise Mocenigo with, on the left, Don Juan of Austria.

7a Pietà
Tempera on panel/29 × 20/s./
1570–2
Philadelphia, John G.
Johnson Collection
7b idem
Oil on canvas/66 × 48/1574–6
New York, Hispanic Society

8a The Purging of the Temple
Tempera on panel/65 × 83/s./
1570–2
Washington, National Gallery
of Art (Kress)
8b idem
Oil on canvas/117 × 150/s./
1570–5
Minneapolis, Institute of Arts

**9 Christ in the House of Mary
and Martha**
Panel/33 × 38/1572*?
Galveston (Texas) (?), Private
Collection
Attribution

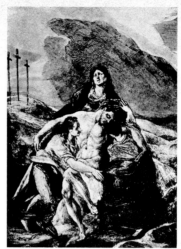

7a

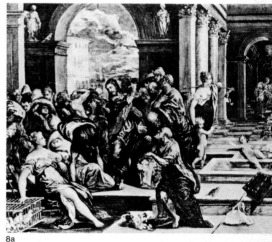

8a

*The Martyrdom of St Maurice
and his Legions (No. 36).
Painted for a chapel in the
Escorial dedicated to the saint,
this work was probably
inspired by a passage in the
GOLDEN LEGEND by Jacobus
de Voraginus which describes
the martyrdom of St Maurice
and of the Theban legions he
led.*

9

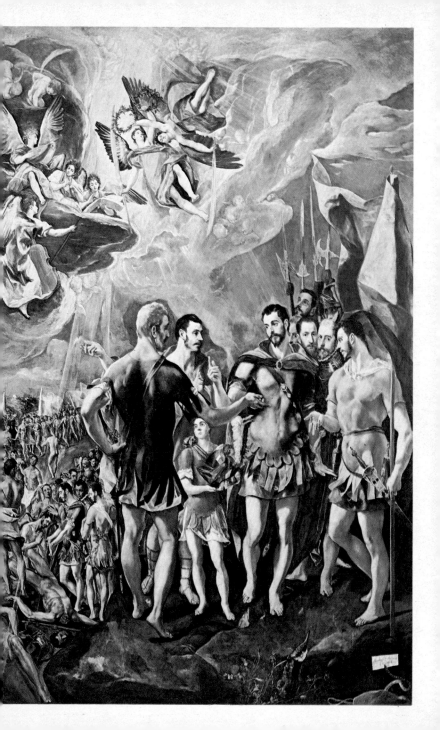

10 The Flight into Egypt
Mixed technique on panel/
17 × 21/*1572*?
Von Hirsch sale, London
1978

11 Portrait of Giulio Clovio
Oil on canvas/58 × 86/s./
1572
Naples, Capodimonte

12 Portrait of Giambattista Porta
Oil on canvas/116 × 98/s./
1572*
Copenhagen, Statens
Museum for Kunst

13a The Annunciation
Tempera on panel/26 × 20/
*1575
Madrid, Prado
13b idem
Oil on canvas/107 × 93/
Barcelona, Muñoz Collection
13c idem
Oil on canvas/117 × 98/
Florence, Contini Bonacossi
Collection
Version of No. 13a with
variations

1

11

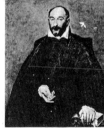

1

The Virgin and Child with St Anne and the Infant St John (No. 41a).
This is a traditional religious subject, probably painted between 1580 and 1585. The artist used the same iconographic treatment a decade later in the Prado canvas (No. 86a).

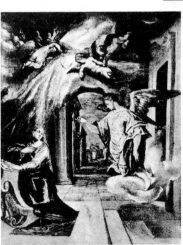

13a

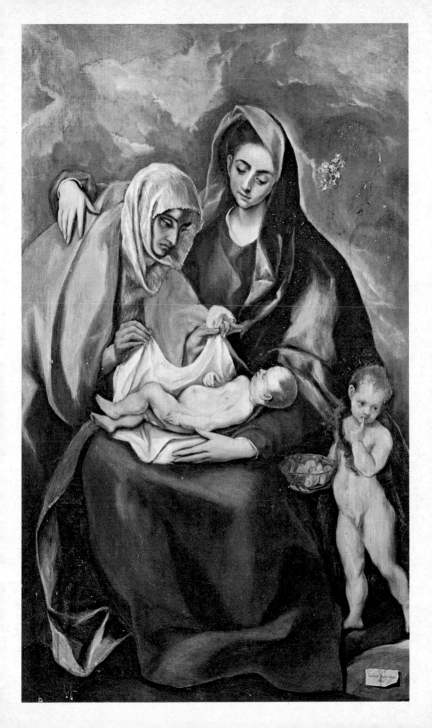

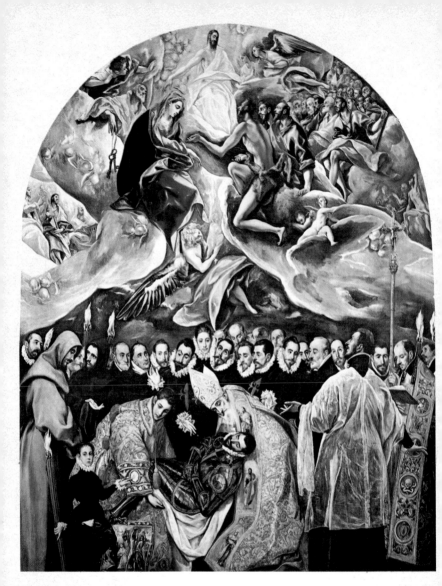

The Burial of the Count of Orgaz (No. 47).

The work illustrates a popular local legend dating from the 14th century, according to which St Augustine and St Stephen miraculously took part in the burial service for Don Gonzalo Ruiz, benefactor of the church of Santo Tomé (the title of Count was in fact conferred on the family at a later date).

The Burial of the Count of Orgaz (No. 47; detail).

Towards the top of the painting an angel accompanies Count Orgaz's soul to heaven; among the saints greeting him and interceding on his behalf is St John the Baptist, kneeling and gazing upwards at the shining figure of the Saviour.

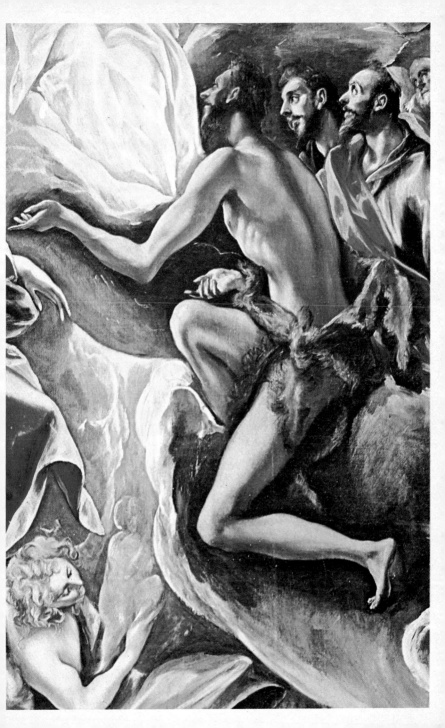

14a Christ healing the Blind
Oil on canvas/50 × 61/s./
1572–6
Parma, Pinacoteca Nazionale
14b idem
Mixed technique on panel/
66 × 84/
Dresden, Gémäldegalerie
Version of No. 14a with
variations

15a Boy lighting a Candle (El Soplón)
Oil on canvas/61 × 51/s./
1575
Manhasset (New York),
Payson Collection
15b idem
Oil on panel/59 × 51/
Naples, Capodimonte

16 The Entombment
Mixed technique on panel/
36.5 × 28/*1576*?
Paris, Broglio Collection

The Burial of the Count of Orgaz (No. 47; detail).
In the lower part of the painting, against a background formed by the heads of eminent citizens present at the miraculous event, is the figure of a priest with his back to us, looking upwards and with arms outstretched; he has been identified as Pedro Ruíz Durón, major domus of the fabric at the church of Santo Tomé.

14a

14b

16

15a

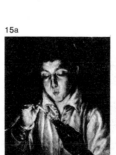

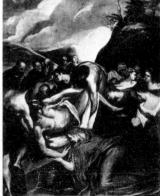

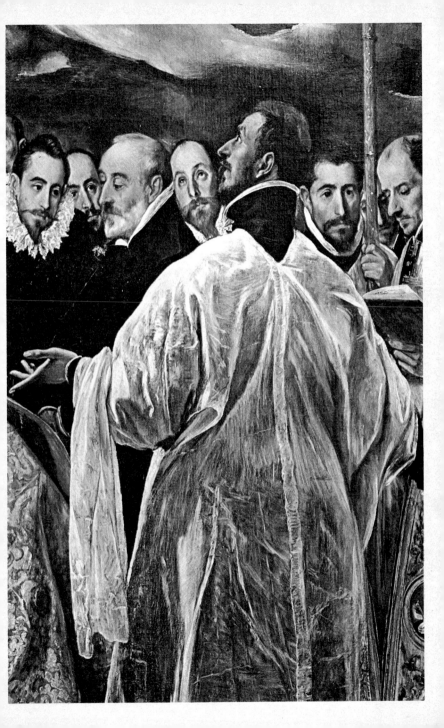

17a St Mary Magdalene in Penitence
Oil on canvas/107 × 102/s./
1577*
Worcester (Mass.), Art
Museum
17b idem
Oil on canvas/104 × 85/
Kansas City (Missouri), W.
Rockill Nelson Gallery of Art

18a Monkey, Boy lighting a Candle, and Man
Oil on canvas/50 × 64/1577*?
New York Art Market (1976)
Probably cut down, especially
on the right-hand side
18b idem
Oil on canvas/65 × 90/s./
1577–8
London, Harewood
Collection

19 Christ healing the Blind Man
Oil on canvas/120 × 146/
1577–8
New York, Wrightsman
Collection
Has some unfinished details
on the left of the picture

20a St Veronica
Oil on canvas/105 × 108/s./
1577–8
Madrid, Caturla Collection
20b idem
Oil on canvas/84 × 91/
Toledo, Museo de Santa Cruz
With probable workshop
contributions

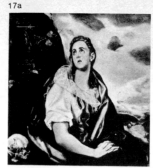
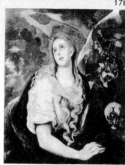

18a

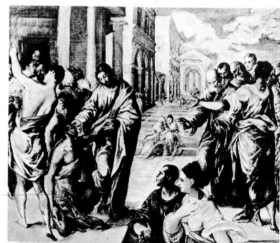

19

The Burial of the Count of Orgaz (No. 47; detail).
At lower centre is the fulcrum
of the whole picture, the
superbly painted waxen face of
the dead man, who is
supported by St Augustine
dressed in resplendent bishop's
vestments.

20a

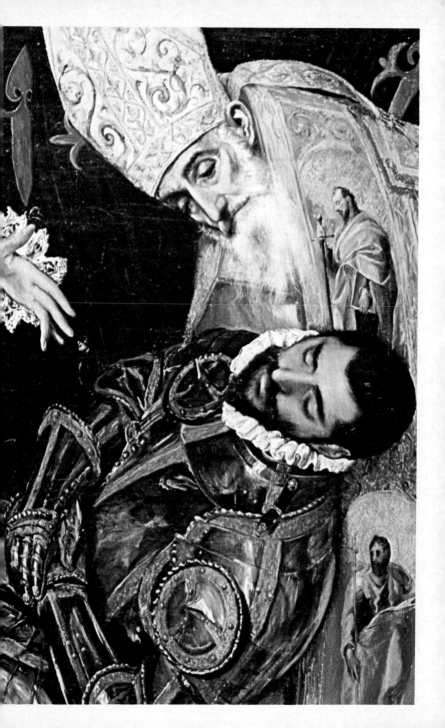

WORKS FOR SANTO DOMINGO EL ANTIGUO AT TOLEDO

21A The Trinity
Oil on canvas/300 × 178/
1577–9
Madrid, Prado

21B St Veronica (The Holy Face)
Oil on panel/76 × 55/1577–9
Madrid, Servera Collection

21C St Bernard
Oil on canvas/113 × 75/
1577–9
Formerly the property of
Simon Oppenheimer; now
lost

21D St Benedict
Oil on canvas/116 × 80/
1577–9
Madrid, Prado

21E St John the Baptist
Oil on canvas/242 × 78/
1577–9
Toledo, Church of Santo
Domingo el Antiguo

21F The Assumption of the Virgin
Oil on canvas/401 × 229/s./
c.1577
Chicago, Art Institute

21G St John the Evangelist
Oil on canvas/212 × 78/
1577–9
Toledo, Church of Santo
Domingo el Antiguo

21H The Adoration of the Shepherds
Oil on canvas/210 × 128/
1577–9
Santander, Botín Sanz
Collection

21I The Resurrection
Oil on canvas/210 × 128/
1577–9
Toledo, Church of Santo
Domingo el Antiguo

The Crucifixion with two Donors (No. 48).
This is one of the artist's earliest known versions of the Crucifixion theme. He did not repeat this iconographic treatment, which includes two donors at the bottom of the canvas.

26

21B

21A

21C

21D

21E

21F

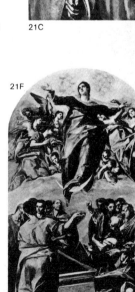

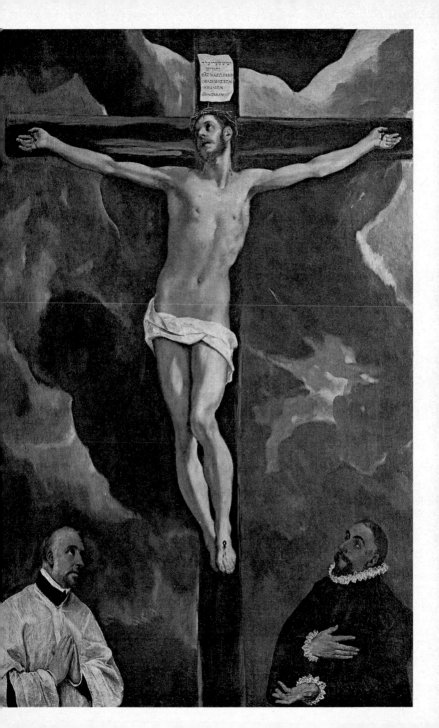

21G

21H

21I

22a The Disrobing of Christ (El Espolio)
Oil on canvas/285 × 173/s./1577–9
Toledo, Cathedral
22b idem
Tempera on panel/56 × 32/s.
Florence, Contini Bonacossi Collection
22c idem
Tempera (?) on panel/55 × 33/s./*1580*
Upton House (Warwickshire), National Trust
22d idem
Oil on canvas/165 × 99/1580–5*
Munich, Alte Pinakothek
22e idem
Oil on panel/72 × 44/
With Knoedler, New York (1976)
22f idem
Oil on canvas/46 × 58/1581–6
Lyons, Musée des Beaux-Arts
Partial replica derived from No. 22d
22g idem
Oil on canvas/136 × 162/*1580*
Bilbao, Delclaux Collection
Partial replica

23 St Anthony of Padua
Oil on canvas/104 × 79/s./1577–9*
Madrid, Prado

24 St Sebastian
Oil on canvas/191 × 152/s./1577–8
Palencia, Cathedral

25 Lady with a Fur
Oil on canvas/62 × 50/1577–8
Glasgow, Museum and Art Galleries (Maxwell MacDonald)

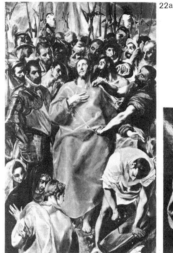
22a

St Peter weeping (No. 56a). One of several versions by El Greco's hand of a devotional theme important in the period of the Counter-Reformation. Workshop copies of the work are also known.

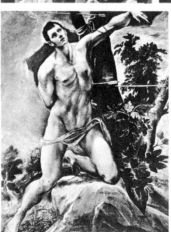
24

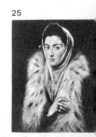
25

28

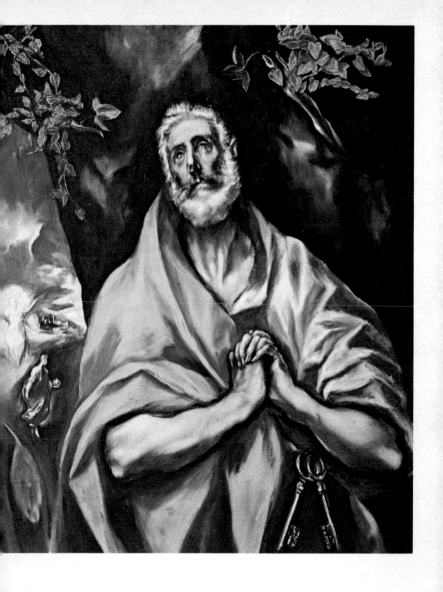

26a St Francis in Ecstasy
Oil on canvas/89 × 57/
1577–80*
Madrid, Museo Lázaro
Galdiano
26b idem
Oil on canvas/87 × 60/s./
1577–80*
New York, property of
Wildenstein & Co
Version of No. 26a with
variations

**27 Portrait of Pompeo Leoni
(?)**
Oil on canvas/92 × 86/
1577–80?
Formerly in New York,
Rosenberg and Stubel
Collection
Attribution

**28 Portrait of Vincentio
Anastagi**
Oil on canvas/188 × 126/s./
1578–80
New York, Frick Collection

29 Knight taking an Oath
Oil on canvas/81 × 66/s./
1578–80*
Madrid, Prado

30 St Paul
Oil on canvas/118 × 91/s./
1578–80*
San Sebastián, Marqués de
Narros Collection

**31 St Lawrence's Vision of the
Virgin**
Oil on canvas/119 × 102/
1578–80*
Monforte de Lemos (Lugo),
Colegio de la Compañia

**St Dominic in Prayer
(No. 61a).**
*One of the earliest versions by
El Greco's hand of another
theme popular during the
Counter-Reformation, and
considered to be one of the
finest examples.*

30

26a

26b

27

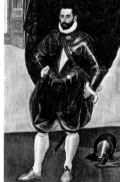

28

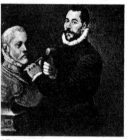

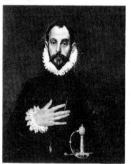

29

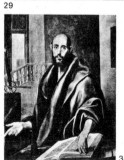

30

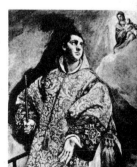

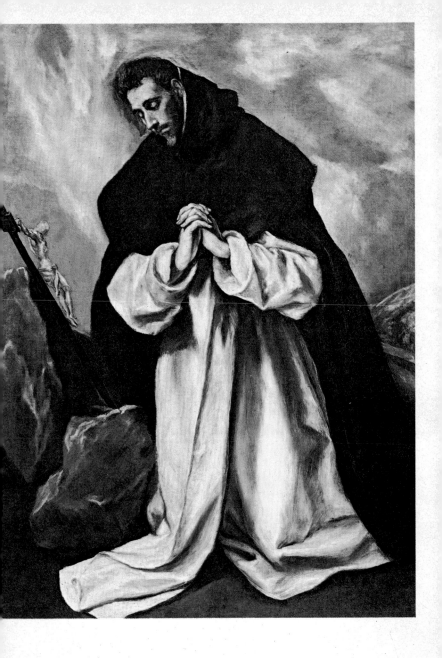

32a Allegory of the Holy League
Oil on canvas/140 × 110/s./
*1579
Escorial, Monastery
32b idem
Oil on panel/58 × 35/s.
London, National Gallery
Study for No. 32a

33a St Mary Magdalene in Penitence
Oil on canvas/156.5 × 121/
*1580
Budapest, Szépmüvészeti
Múzeum
33b idem
Oil on panel/60 × 45/
Barcelona, Sala Ardiz
Collection

34 Portrait of a Lady
Oil on panel/40 × 32/1577–80
Philadelphia, John G.
Johnson Collection

35 The Dead Christ, supported by Joseph of Arimathaea, with the Virgin and the Magdalene (Pietà)
Oil on canvas/120 × 145/s./
1578–85
Paris, Niarchos Collection

33a

32a
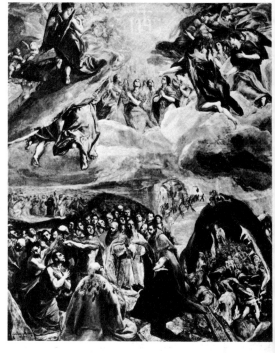

34

35

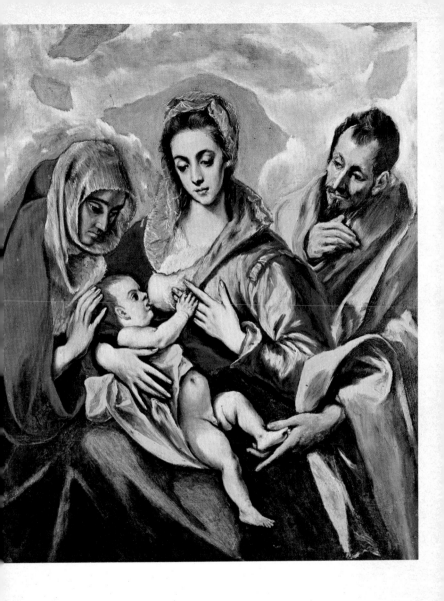

**The Holy Family with St Anne
(No. 73a).**
*At various times during his
career El Greco turned, as if in
a moment of serene
inspiration, to the subject of
the Holy Family group,
centred on the very human
figure of the Virgin.*

36 The Martyrdom of St Maurice and his Legions
Oil on canvas/448 × 301/s./1580–2
Escorial, Monastery

37 Portrait of a Gentleman of the House of Leiva (Knight of the Order of Santiago)
Oil on canvas/88 × 69/1580*
Montreal, Museum of Fine Arts

38 St Aloysius Gonzaga (?)
Oil on canvas/74 × 75/1580–5
Santa Barbara (California), Converse Collection

39 Portrait of a Gentleman
Oil on canvas/66 × 55/1580–5
Madrid, Prado

40 The Immaculate Conception with St John the Evangelist
Oil on canvas/236 × 118/s./1580–5
Toledo, Museo de Santa Cruz

41a Virgin and Child with St Anne and the Infant St John
Oil on canvas/178 × 105/s./1580–5
Toledo, Museo de Santa Cruz
41b idem
Oil on canvas/90 × 80/1580–5*
Hartford (Connecticut), Wadsworth Atheneum
The bottom part of the canvas, with the Infant St John, is missing

The Crucifixion with the Virgin, St Mary Magdalene, St John the Evangelist and Angels (No. 75).
This painting, which can be dated to the last decade of the 16th century, is a supreme example of El Greco's innovatory handling of this traditional religious theme.

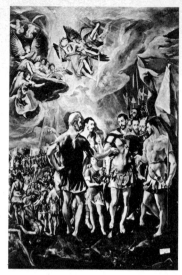

36

37

38

39

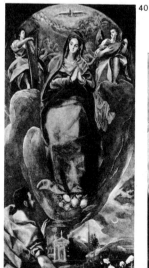

40

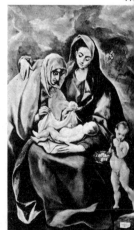

41

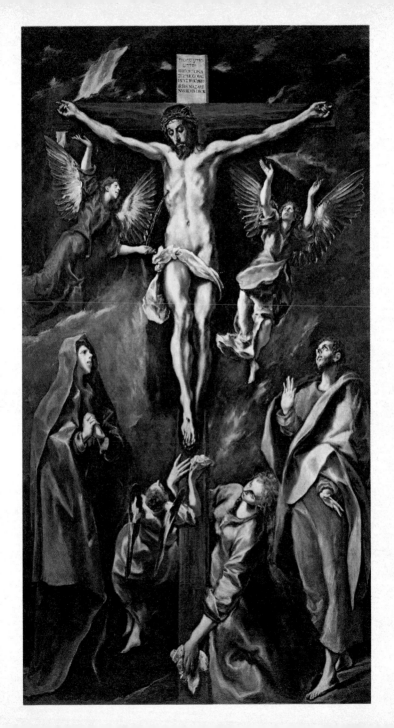

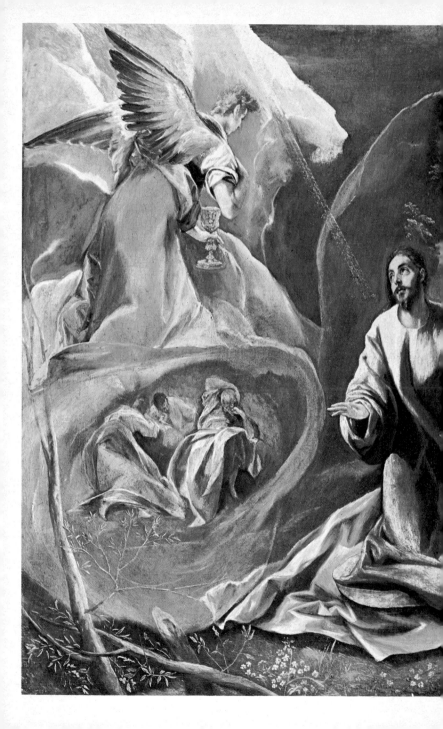

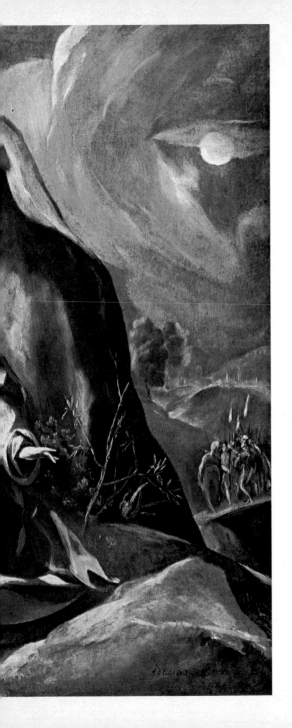

The Agony in the Garden (No. 78a).
The episode from the Scriptures is set out horizontally in a continuous composition: within a cavity in a rock, which seems to be almost carved out of the angel's robe, the apostles lie asleep; far off, behind the praying Christ, are the figures of soldiers.

37

42

42 The Holy Family
Oil on canvas/106 × 88/
1585–90
New York, Hispanic Society

43a St Francis standing in Meditation
Oil on canvas/116 × 102/s./
1580–90
Omaha (Nebraska), Joselyn
Art Museum
43b idem
Oil on canvas/103 × 87/s./
1585–90
Barcelona, Torelló Collection

43a

44 Julián Romero de las Azañas and St Julian (Julián Romero and his Patron Saint)
Oil on canvas/207 × 127/
1585–90
Madrid, Prado

45 Portrait of Rodrigo de la Fuente (the Physician)
Oil on canvas/93 × 84/s./
1585–9
Madrid, Prado

46 Portrait of an Elderly Gentleman
Oil on canvas/44 × 42/s./
1585–90
Madrid, Prado

45

44 46

47 The Burial of the Count of Orgaz
Oil on canvas/460 × 360/s./
1586–8
Toledo, Church of Santo Tomé

48 Crucifixion with Two Donors
Oil on canvas/250 × 180/s./
1585–90
Paris, Louvre

49 St Mary Magdalene in Penitence
Oil on canvas/109 × 96/s./
1585–90
Sitges, Cau Ferrat Museum

The Virgin and Child with St Martina and St Agnes (No. 92D).
The canvas is one of a series of paintings which El Greco made in the last years of the 16th century for the small chapel of San José in Toledo, built with a legacy from the merchant Martín Ramírez.

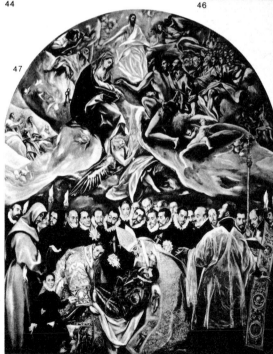

47

38

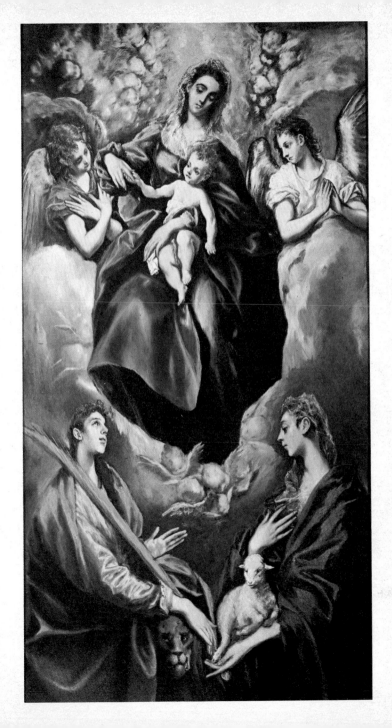

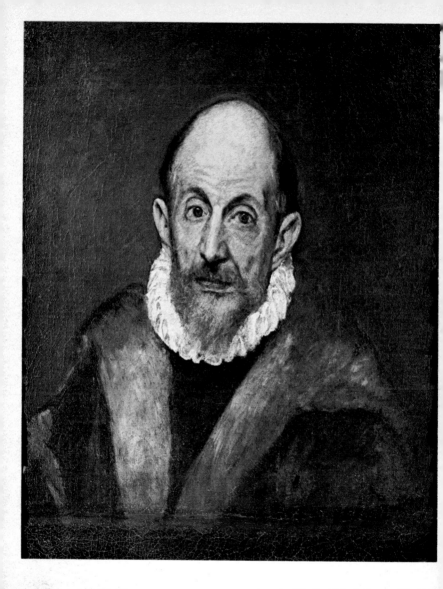

Self-Portrait (?) (No. 95).
*Traditionally identified as a
portrait of the artist in old
age, this is without a doubt one
of the finest examples of his
portrait-painting.*

Portrait of Cardinal Niño de Guevara (No. 97a).
*The austere and powerful image of one of the
most eminent personalities of the Spanish church
at that time; formerly Archbishop of Toledo and
later Grand Inquisitor.*

St John the Baptist (No. 105a). (p. 43)
*This is a subject which El Greco used many times
during his career. The critics agree in judging this
version, which can be dated to the early years of
the 17th century, as one of the best examples.*

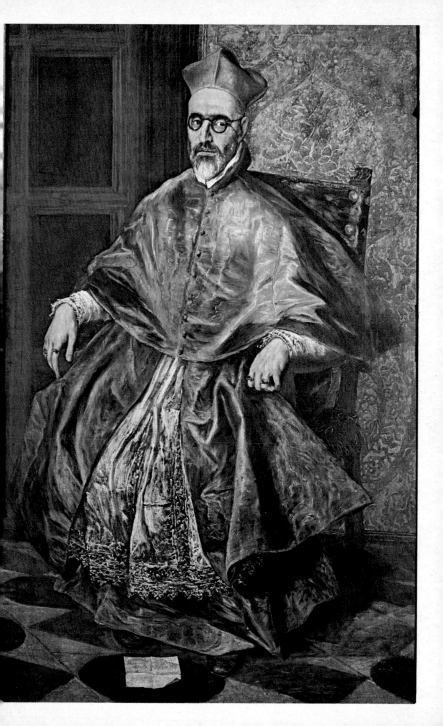

50 Portrait of Rodrigo Vázquez
Oil on canvas/62 × 40/
1585–90
Madrid, Prado

51a St Francis receiving the Stigmata
Oil on canvas/108 × 83/s./
1585–90
Madrid, Marqués de Pidal
Collection
51b idem
Oil on canvas/101 × 76/
Escorial, Monastery
51c idem
Oil on canvas/104 × 80/
Stockholm, Sachs Collection
Attribution
51d Replica of No. 51a
Oil on canvas/122 × 104/
Formerly at The Hague,
Bachstitz Collection
51e idem
Oil on canvas/114 × 105/
1580–90
Dublin, National Gallery of
Ireland
51f idem
Oil on canvas/141 × 110/
1580–6
San Sebastián, Museo
Municipal de San Telmo
51g idem
Oil on canvas/57 × 44/
Bilbao, Museo de Bellas
Artes
Replica of saint's head and
shoulders only

52a Mater dolorosa
Oil on canvas/62 × 42/
1585–90
Berlin-Dahlem, Staatliche
Museen
52b idem
Oil on canvas/63 × 48/
Lugano, Thyssen Collection

53a Christ taking leave of his Mother
Oil on canvas/109 × 99/
1585–90
Gorton (Mass.), Danielson
Collection
53b idem
Oil on canvas/24 × 21/1590*
Formerly at Sinaia
(Romania), Royal Palace
53c idem
Oil on canvas/100 × 118/
Rotterdam, Museum
Boymans-van Beuningen
Version of No. 53a with
variations

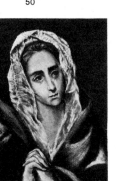

48

49

50

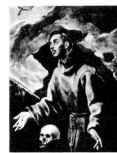

51a

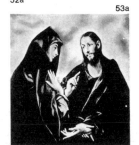

52a

54a

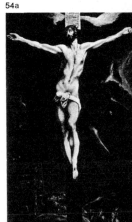

53a

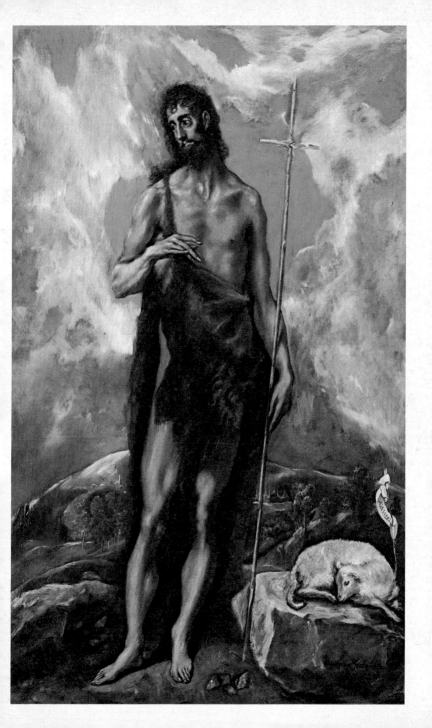

55

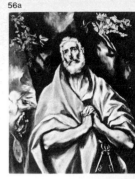
56a

54a Christ on the Cross
Oil on canvas/177 × 105/
1585–95
Zumaya, Zuloaga Collection
54b idem
Oil on canvas/178 × 104/
1585–95
Saville, Marqués de la
Motilla Collection
54c idem
Oil on canvas/193 × 116/
1600–10
Cleveland (Ohio), Museum of
Art
54d idem
Oil on canvas/208 × 102/
1600–10
Philadelphia, Museum of Art
(Wilstach)
54e idem
Oil on canvas/95 × 61/s. (?)
New York, Property of
Wildenstein & Co

55 St Louis of France
Oil on canvas/117 × 95/
1585–90
Paris, Louvre

56a St Peter weeping
Oil on canvas/106 × 88/s./
1585–90
Barnard Castle (Co.
Durham), Bowes Museum
56b idem
Oil on canvas/122 × 102/s./
1590
San Diego (California), Fine
Arts Gallery
56c idem
Oil on canvas/94 × 76/*1600*
Washington, Phillips
Memorial Gallery
56d idem
Oil on canvas/100 × 96/
1600
Toledo, Cathedral (Sacristy)
56e idem
Oil on canvas/102 × 84/s./
1605*
Toledo, Tavera Hospital
With variations
56f idem
Oil on canvas/102 × 80/s./
1610*
Oslo, Nasjonalgalleriet

HENKE SERIES
57A The Saviour
Oil on canvas/62 × 50/
1586–90*
Beverly Hills (California),
José Iturbi Collection

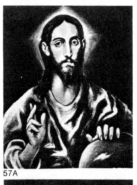
57A

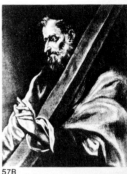
57B

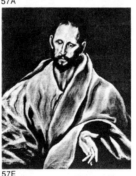
57E

57F

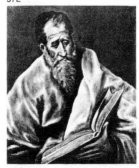
57H

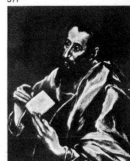
57I

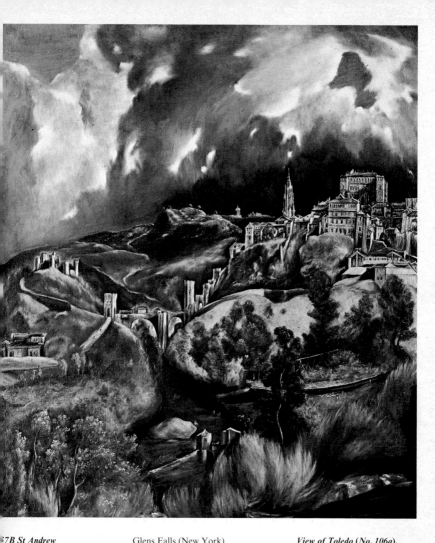

57B St Andrew
Oil on canvas/62 × 50/
1586–90*
Washington, Corcoran
Gallery of Art
57C St Bartholomew (?)
Oil on canvas/62 × 50/
1586–90
Destroyed by fire in 1950
57D St James Major
Oil on canvas/62 × 50/
1586–90*
Location not known
57E St James Minor
Oil on canvas/62 × 50/
1586–90*

Glens Falls (New York),
L. F. Hyde Collection
57F St John the Evangelist
Oil on canvas/62 × 50/
1586–90*
Formerly in Amsterdam, De
Boer Collection
57G St Judas Thaddaeus
Oil on canvas/62 × 50/
1586–90
Beverly Hills (California),
José Iturbi Collection
57H St Matthew
Oil on canvas/62 × 50/
1586–90*
Indianapolis, W. Herrington

View of Toledo (No. 106a).
The walled city standing high
on its rock with the Tagus
flowing below is the subject of
this landscape painting which
is steeped in an atmosphere of
dramatic suspense.

45

57I St Paul
Oil on canvas/62 × 50/
1586–90*
Sarasota (Florida), Ringling
Museum
57i idem
Oil on canvas/70 × 56/s./
1598–1600
Saint Louis (Missouri), City
Art Museum
Replica of No. 57I. Pendant
to No. 132
57J St Peter
Oil on canvas/62 × 50/
1586–90
Hollywood, L. Meyer
Collection
57K St Philip
Oil on canvas/62 × 50/
1586–90*
New York, I. Brenner
Collection
57L St Simon
Oil on canvas/62 × 50/
1586–90*
Boston, E. H. Abbott Jr.
Collection
57M St Thomas
Oil on canvas/62 × 50/
1586–90
Johannesburg, Art Gallery

**58a St James Major as a
Pilgrim**
Oil on canvas/123 × 70/
1580–95
Toledo, Museo de Santa Cruz
58b idem
Oil on canvas/62 × 32/s./
1580–1600
New York, Hispanic Society

59 St Augustine
Oil on canvas/140 × 56/
1580–95
Toledo, Museo de Santa Cruz

**60a St Francis receiving the
Stigmata**
Oil on canvas/107 × 87/s./
1585–95
Escorial, Monastery
The canvas has been cut
down
60b idem
Oil on canvas/102 × 97/s.
Baltimore, Walters Art
Gallery

61a St Dominic in Prayer
Oil on canvas/118 × 86/s./
1585–95?
Madrid, J. Urquijo Chacón
Collection

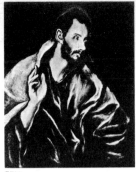
57M

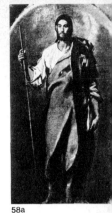
58a

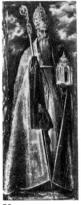
59

60a

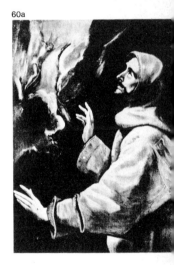

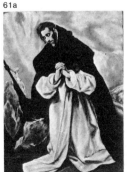
61a

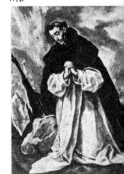
61b

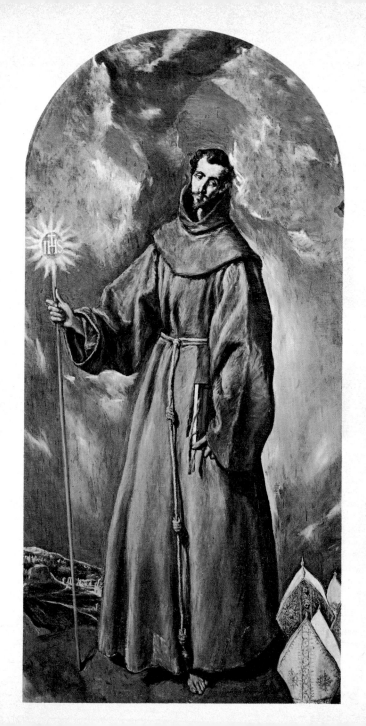

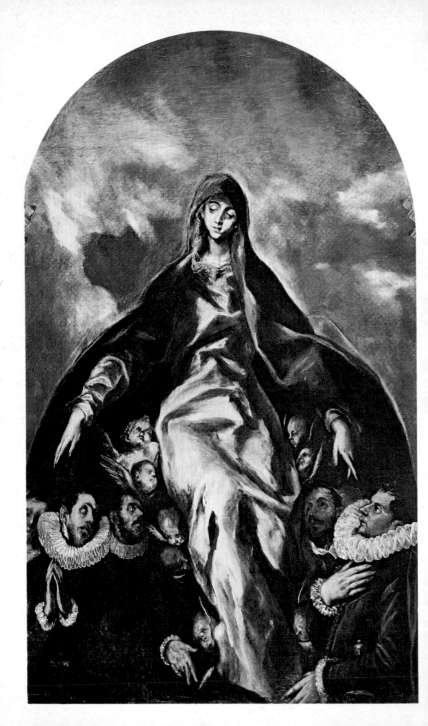

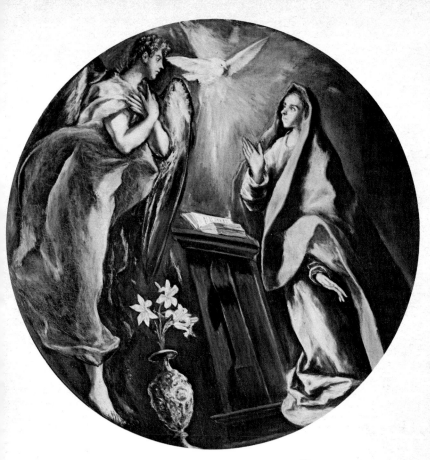

The Annunciation (No. 111C).
This tondo, *which also belongs to the cycle carried out for the Illescas church in the early years of the 17th century, is painted with exceptional freedom. The handling of perspective, which is the same as that in No.111D, suggests that the work originally decorated the presbytery vault.*

St Bernardino (No. 110). (p. 47)
Painted at the beginning of the 17th century for the chapel of the college of San Bernardino in Toledo, the work clearly shows El Greco's stylistic development at this stage of his maturity.

The Madonna of Charity (No. 111A).
Painted for the church of the Hospital of Charity at Illescas, a small town half-way between Toledo and Madrid. Among the figures gathered under the Virgin's mantle is, on the right, the artist's son, Jorge Manuel.

61b idem
Oil on canvas/120 × 88/s./
1585–1603
Toledo, Cathedral (Sacristy)
61c idem
Oil on canvas/105 × 83/s./
1600–10
Boston, Museum of Fine Arts
Replica of No. 61a with
variations
61d idem
Oil on canvas/73 × 57/
1590–1610
Florence, Contini Bonacossi
Collection
El Greco and workshop

***62 The Coronation of the
Virgin***
Oil on canvas/90 × 100/s./
1590*
Madrid, Prado

***63 Portrait of Manusso
Theotocopoulos (?)***
Oil on canvas/47 × 39/1591*?
Florence, Contini Bonacossi
Collection

***WORKS FOR TALAVERA
LA VIEJA PARISH
CHURCH*** (Toledo, Museo de
Santa Cruz)
***64A The Coronation of the
Virgin***
Oil on canvas/105 × 80/
1591–2
El Greco and workshop
64B St Andrew
Oil on canvas/126 × 46/
1591–2
El Greco and workshop
64C St Peter
Oil on canvas/125 × 46/
1591–2
El Greco and workshop

65a St Francis in Ecstasy
Oil on canvas/75 × 57/
1590–5
Pau, Musée des Beaux-Arts
El Greco and workshop
65b idem
Oil on canvas/110 × 87/s.
Toledo, Conde de
Guendulain y del Vado
Collection
El Greco and workshop

62

63

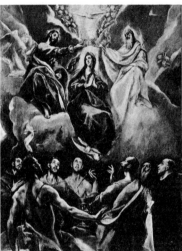

64A

64B

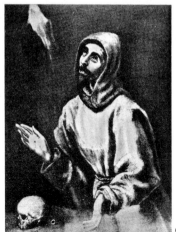

64C

65a

50

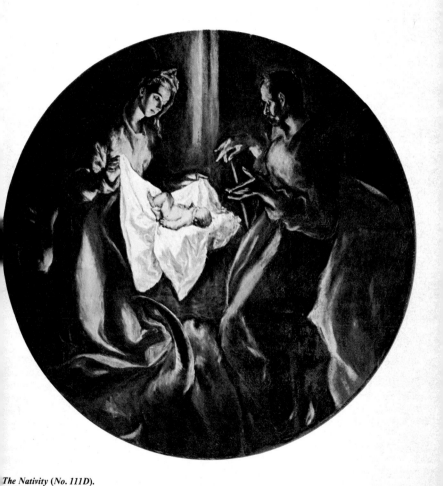

The Nativity (No. 111D).
This is the other tondo *which was probably originally placed in a lunette at the side of the large oval* CORONATION OF THE VIRGIN *in the vault of the Illescas church, with the* ANNUNCIATION *(No. 111C) occupying the lunette on the other side.*

St Ildefonso (No. 111E). (p. 53)
This painting, on the side altar on the left of the church at Illescas, is a portrait-like representation of the saint's very human personality as well as of his spiritual nature.

66 Crucifixion with St John the Evangelist, the Madonna and a Donor
Oil on canvas/174 × 111/
1590–5?
Martín Muñoz de las Posadas
(Segovia), Parish Church

67 The Birth of the Virgin
Oil on canvas/62 × 35.5/
1590–5
Zürich, Bührle Foundation

68a Head of Christ
Oil on canvas/61 × 41/s./
1590–5
Prague, Národni Galerie
68b idem
Oil on canvas/50 × 39/
1585–90
San Antonio (Texas), McNay
Art Institute
68c idem
Oil on canvas/62 × 47/1590*
San Sebastián, Museo
Municipal de San Telmo

69a Christ carrying the Cross
Oil on canvas/105 × 79/s./
1590–5
New York, Metropolitan
Museum (Lehman
Collection)
69b idem
Oil on canvas/111 × 72/
1590–5
Paris, Gutzwiller Collection
69c idem
Oil on canvas/81 × 59/s./
1590–5
Buenos Aires, Museo
Nacional de Arte Decorativo
Reduced replica of No. 69a
69d idem
Oil on canvas/48 × 38/s./
1590–5
Cuenca, Cathedral (Treasury)
Probably cut down on all
four sides
69e idem
Oil on canvas/105 × 67/s./
1590–5
Barcelona, Museo de Arte de
Cataluña
69f idem
Oil on canvas/115 × 71/s. (?)/
*1591
Formerly at Sinaia
(Romania), Royal Palace
69g idem
Oil on canvas/53 × 38/s./
1590–5
Athens, National Picture
Gallery

66

67

68a

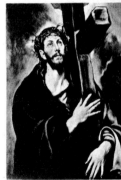

69a

70a

70b

70c

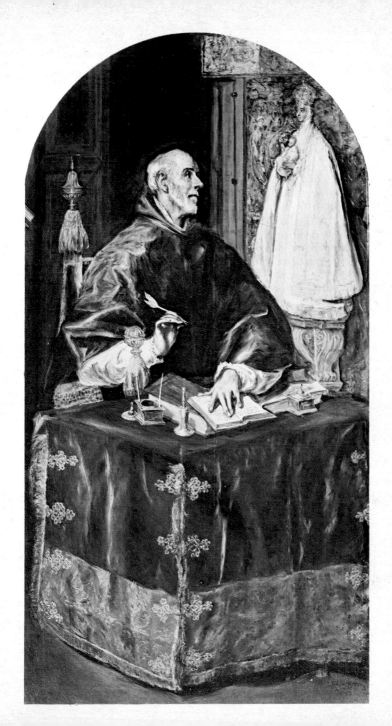

69h idem
Oil on canvas/104 × 78/s./
1590–1605
Madrid, Prado
69i idem
Oil on canvas/94 × 78/s./
1600*
Olot (Gerona), Church of
San Estéban
69j idem
Oil on canvas/101 × 80/s./
1600*
El Bonillo (Albacete), Parish
Church of Santa Catalina
69k idem
Oil on canvas/63 × 48/
Cambridge (Mass.), Fogg Art
Museum

70a Christ carrying the Cross
Oil on canvas/65 × 53/s./
1590–5
New York, Brooklyn
Museum
70b idem
Oil on canvas/67 × 50/s.
Getafe (Madrid), Mengs
Collection
70c idem
Oil on canvas/23 × 18/1600*
Indianapolis, G. H. A.
Clowes Foundation
Reduced replica of No. 70a
70d idem
Oil on canvas/66 × 52.5/s./
1600*
Lugano, Thyssen Collection

71 Lady with a Flower in her Hair
Oil on canvas/50 × 42/s./
1582–1600
London, Warwick House,
Rothermere Collection

72 Portrait of Gaspar de Quiroga
Oil on canvas/64 × 51/*1594*
Formerly in Munich, Böhler
Collection

73a The Holy Family with St Anne
Oil on canvas/127 × 106/
1595
Toledo, Tavera Hospital
73b idem
Oil on canvas/138 × 103.5/
Budapest, Szépmüvészeti
Múzeum

74 St Andrew and St Francis
Oil on canvas/167 × 113/s./
1590–1600
Madrid, Prado

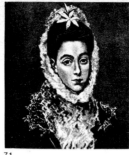
71

72

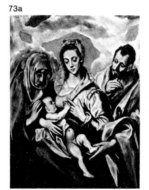
73a

74

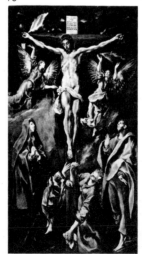
75

76

54

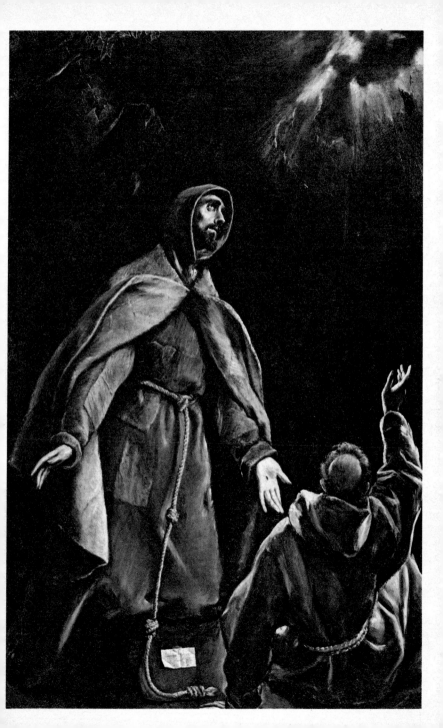

75 Crucifixion with the Virgin, St Mary Magdalene, St John the Evangelist and Angels
Oil on canvas/312 × 169/s./
1590–1600
Madrid, Prado

76 St Andrew
Oil on canvas/110 × 65/
1590–1600
New York, Metropolitan Museum

77 Portrait of a Gentleman
Oil on canvas/51 × 33/
1590–1600?
Formerly in the Wertheimer Collection

78a The Agony in the Garden
Oil on canvas/102 × 114/s./
1590–8
Toledo (Ohio), Museum of Art
78b idem
Oil on canvas/102 × 131/
1590–1600
London, National Gallery
78c idem
Oil on canvas/100 × 143/
1605–14
Bilbao, F. Valdés Izaguirre Collection
The canvas has been cut down

79 The Holy Family with St Mary Magdalene
Oil on canvas/131 × 100/
1590–1600
Cleveland (Ohio), Museum of Art

80a The Virgin
Oil on canvas/52 × 36/s./
1594–1600
Strasbourg, Musée des Beaux-Arts
80b idem
Oil on canvas/52 × 41/s./
1594–1600
Madrid, Prado

81 Head of Man (St James Minor?)
Oil on canvas/49.5 × 42.5/
1595–1600
Budapest, Szépművészeti Múzeum

82 St James Major as a Pilgrim
Oil on canvas/43 × 37/
1595–1600
New York, Hispanic Society

77

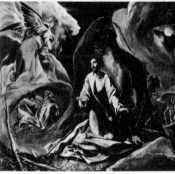
78a

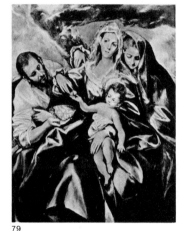
79

80a

80b

81

82

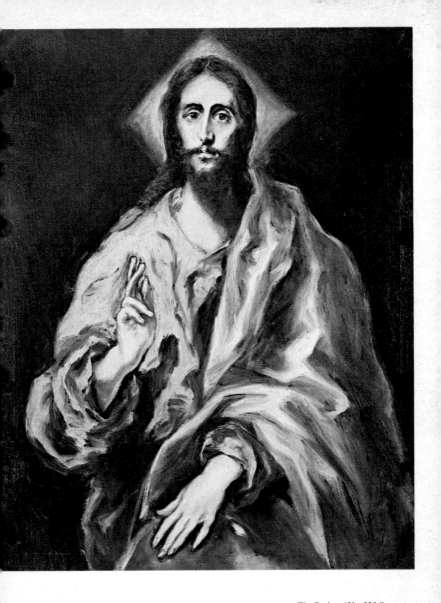

***83a The Purging of the
Temple***
Oil on canvas/42 × 53/
1595–1605
New York, Frick Collection
83b idem
Oil on canvas/106 × 130/
1600–10
London, National Gallery

84a St Francis in Ecstasy
Oil on canvas/101 × 89/s./
1580–1614?
Madrid, C. Blanco Soler
Collection
El Greco and workshop
84b idem
Oil on canvas/50 × 40/
1605–14
Madrid, F. Araoz Collection
84c idem
Oil on canvas/109 × 79/s.
Montreal, Museum of Fine
Arts
Attribution

85a St Jerome as Cardinal
Oil on canvas/111 × 96/s./
1584–1610?
New York, Frick Collection
85b idem
Oil on canvas/30 × 24/
1600–10
Bayonne, Musée Bonnat
Replica of No. 85a limited to
saint's head and shoulders
85c idem
Oil on canvas/108 × 87/
1600–10
New York, Metropolitan
Museum (Lehman
Collection)
85d idem
Oil on canvas/59 × 48/
1575–1600
London, National Gallery
El Greco and workshop

83a

83b

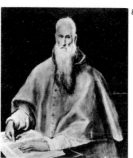
84a

84b

85a

85b

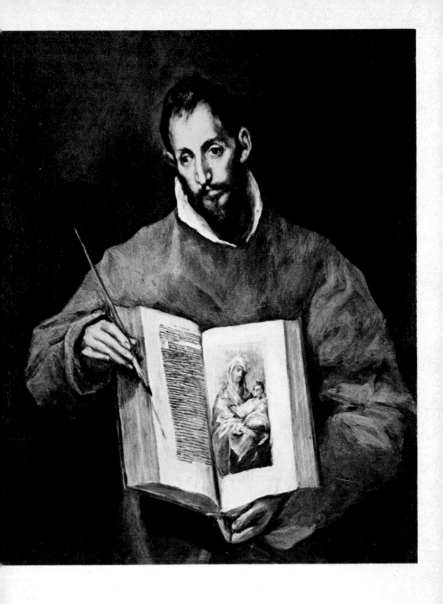

St Luke (No. 116H).
An intense image, which some scholars believe to be a self-portrait. This too belongs to the Toledo Cathedral Apostle series.

86a The Holy Family with St Anne and the Infant St John
Oil on canvas/107 × 69/s./
1590–1600
Madrid, Prado
86b idem
Oil on canvas/52 × 33/*1600*
Washington, National
Gallery of Art (Kress)

87 St Peter and St Paul
Oil on canvas/120 × 92/
1590–1600
Barcelona, Museo de Arte de
Cataluña

88 St Dominic in Prayer in his Cell
Oil on canvas/57 × 57/s./
1590–1600
Newport (Rhode Island), J.
Nicholas Brown Collection
El Greco and workshop

89a St Francis kneeling in Meditation
Oil on canvas/147 × 105/s./
1595–1600
San Francisco, M. H. de
Young Memorial Museum
89b idem
Oil on canvas/105 × 86/s.
Bilbao, Museo de Bellas
Artes
89c idem
Oil on canvas/93 × 74/s./
1595–1604
Chicago, Art Institute
89d idem
Oil on canvas/121 × 93/s./
1585–1604
Lille, Palais des Beaux-Arts
Cut down on all four sides

90 St John the Evangelist
Oil on canvas/90 × 77/
1595–1604
Madrid, Prado

91 The Saviour
Oil on canvas/72 × 57/s./
1596–1600
Edinburgh, National Gallery
of Scotland

86a

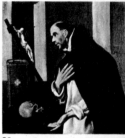

86b

87

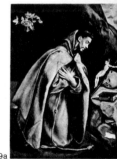

88

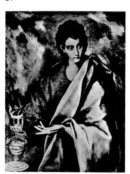

89a

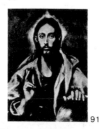

90

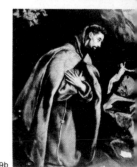

91

89b

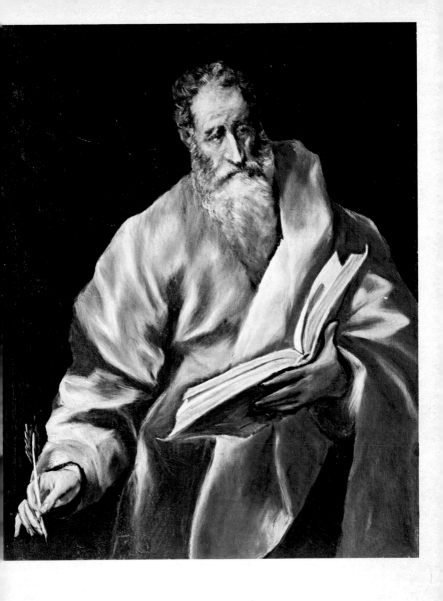

St Matthew (No. 116I).
This is considered to be one of the most forceful and inspired paintings of the Toledo Cathedral APOSTOLADO, *to which it belongs, even though the subject here is one of the evangelists and not an apostle.*

WORKS FOR THE CHAPEL OF SAN JOSÉ AT TOLEDO

92A The Coronation of the Virgin
Oil on canvas/120 × 147/
1597–9
Toledo, Chapel of San José

92B St Joseph and the Infant Christ
Oil on canvas/289 × 147/s./
1597–9
Toledo, Chapel of San José

92b idem
Oil on canvas/109 × 56/s./
1595–9
Toledo, Museo de Santa Cruz
May be a preparatory study
for No. 92B

92C St Martin and the Beggar
Oil on canvas/193 × 103/s./
1597–9
Washington, National
Gallery of Art (Widener)

92D Virgin and Child with St Martina and St Agnes
Oil on canvas/193 × 103/s./
1597–9
Washington, National
Gallery of Art (Widener)

93a St Jerome in Penitence
Oil on canvas/104 × 97/
1595–1600
Edinburgh, National Gallery
of Scotland

93b idem
Oil on canvas/105 × 90/
1587–1600*
Madrid, Marqúes de Santa
María de Silvela y de
Castañar Collection
Pendant to No. 107

93c idem
Oil on canvas/80 × 65/s./
1600–10
New York, Hispanic Society

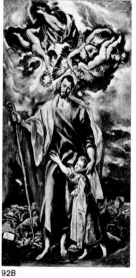
92A

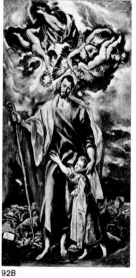
92B

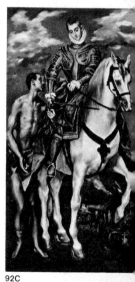
92C

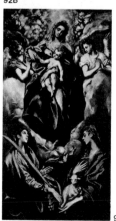
92D

93a

93b

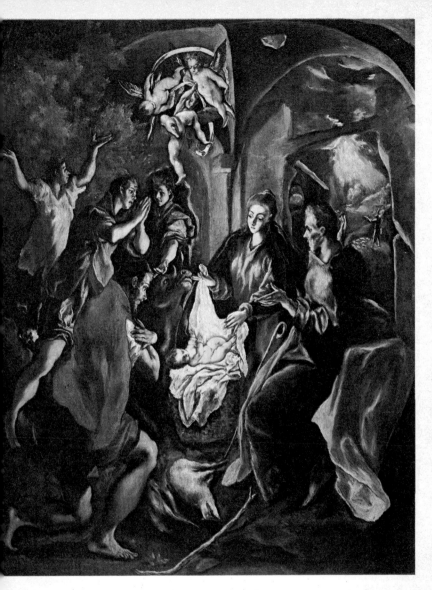

The Adoration of the Shepherds (No. 119a).

This canvas can be dated with some accuracy because its free-flowing, transfiguring treatment of the theme is faithfully reproduced in an engraving of 1605. The subject later reappears in the replica by El Greco's own hand, now in the Metropolitan Museum in New York.

WORKS FOR THE COLEGIO DE DOÑA MARIA DE ARAGÓN IN MADRID

94A The Adoration of the Shepherds
Oil on canvas/346 × 137/s./
1597–1600
Bucharest, Romanian
National Museum

94a idem
Oil on canvas/111 × 47/
Rome, Palazzo Barberini,
Galleria Nazionale
Replica of No. 94A. Pendant
to No. 94c

94B The Annunciation
Oil on canvas/315 × 174/s./
1597–1600
Villanueva y Geltrú, Museo
Balaguer (on loan from the
Prado)

94b idem
Oil on canvas/114 × 67/s.
Lugano, Thyssen Collection
Study for No. 94B. Cut down
at the bottom

94b(i) idem
Oil on canvas/110 × 65/
Bilbao, Museo de Bellas
Artes
Replica of No. 94B

94C The Baptism of Christ
Oil on canvas/350 × 144/s./
1597–1600
Madrid, Prado

94c idem
Oil on canvas/111 × 47/
Rome, Palazzo Barberini
Galleria Nazionale
Pendant to No. 94a

95 Self-Portrait (?)
Oil on canvas/59 × 46/
1590–1600
New York, Metropolitan
Museum of Art (Rogers)

96 Portrait of a Gentleman
Oil on canvas/74 × 74/s./
1592–1603*
Glasgow, Pollok House,
Museum and Art Galleries
(Stirling-Maxwell)
Cut down on all four sides

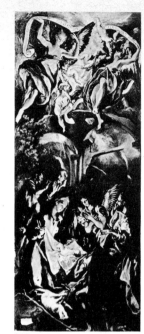

94A

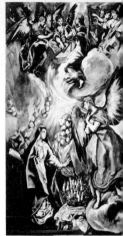

94B

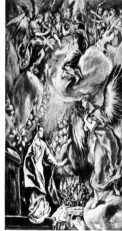

94C

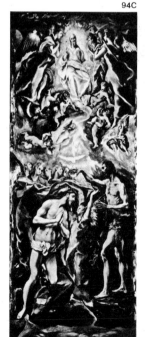

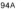

94b

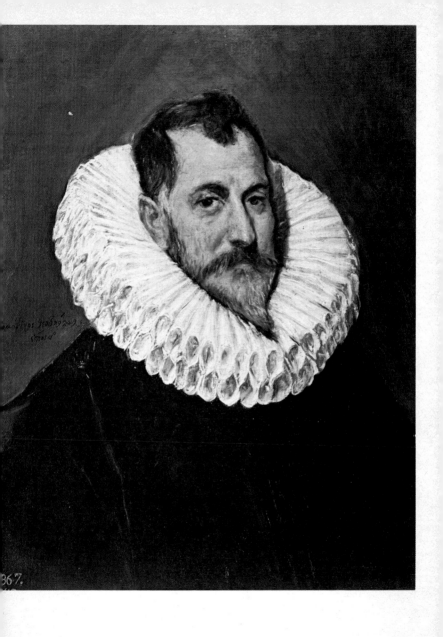

Portrait of a Gentleman (*No. 123*).
*The painting can be dated to the first decade of the
17th century; it is one of the series of ideal
portraits of people of rank which El Greco
executed in a traditional 16th century manner,
giving them a monumental air.*

97a Portrait of Cardinal Niño de Guevara
Oil on canvas/171 × 108/s./
1596–1600
New York, Metropolitan
Museum of Art (Havemeyer)
97b idem
Oil on canvas/74 × 51/s.
Winterthur, Reinhart
Collection
Partial replica of No. 97a

98a Allegory of the Order of the Camaldolesi
Oil on canvas/138 × 108/
1597*
Valencia, Colegio del
Patriarca
El Greco and workshop
98b idem
Oil on canvas/124 × 90/
Madrid, Instituto de Valencia
de Don Juan
El Greco and workshop

99 Portrait of Alonso de Herrera
Oil on canvas/79 × 64/
1595–1605
Amiens, Musée de Picardie

100a Portrait of Antonio de Covarrubias
Oil on canvas/65 × 52/s./
1600*
Paris, Louvre
100b idem
Oil on canvas/67 × 55/s./
1600
Toledo, Museo del Greco

101 Portrait of Diego de Covarrubias
Oil on canvas/67 × 55/1600*
Toledo, Museo del Greco
El Greco and workshop

102 Portrait of Jorge Manuel Theotocopoulos
Oil on canvas/81 × 56/s./
1600–5
Seville, Museo Provincial de
Bellas Artes

*The Resurrection (No. 129a).
Most critics think the painting
originally formed a companion
to the PENTECOST (No. 130),
which it resembles in size and
in the expressionistic
elongation of the figures.*

96

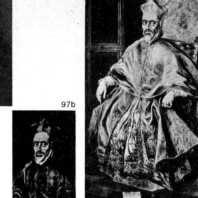
97a

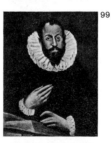
97b

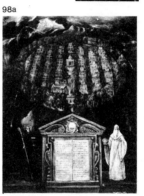
98a

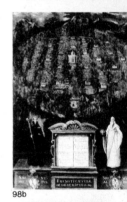
98b

99

100a

101

102

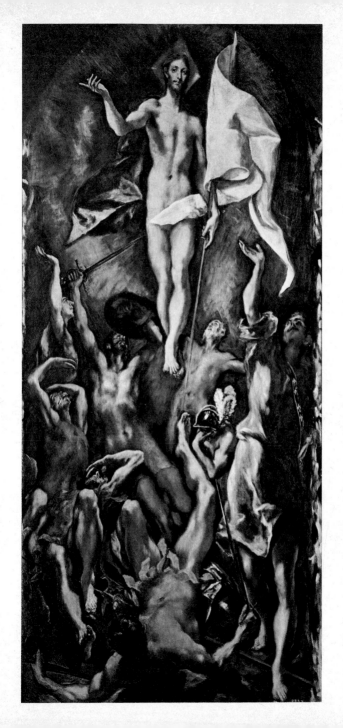

ALMADRONES APOSTLE SERIES (El Greco and Workshop)

103A The Saviour
Oil on canvas/72 × 55/1600*
Madrid, Prado

103B St Andrew
Oil on canvas/72 × 55/1600*
Los Angeles, County Museum

103b idem
Oil on canvas/70 × 53.5/s./1600–14
Budapest, Szépmüvészeti Múzeum
Replica of No. 103B

103C St James Major
Oil on canvas/72 × 55/s./1600
Madrid, Prado

103c idem
Oil on canvas/70 × 54/s./1595–1614
Oxford, New College (Chapel)
Replica of No. 103C

103D St John the Evangelist
Oil on canvas/72 × 55/s./1600*
Fort Worth (Texas), Kimbell Art Foundation

103E St Luke (St Bartholomew?)
Oil on canvas/72 × 55/s./1600*
Indianapolis, G. H. A. Clowes Foundation

103F St Matthew
Oil on canvas/72 × 55/s./1600*
Indianapolis, G. H. A. Clowes Foundation

103G St Paul
Oil on canvas/72 × 55/1600*
Madrid, Prado

103H St Simon
Oil on canvas/72 × 55/s./1600*
Indianapolis, G. H. A. Clowes Foundation

103I St Thomas (St. Philip?)
Oil on canvas/72 × 55/s./1600*
Madrid, Prado

*The Pentecost (No. 130).
Probably painted as companion to No. 129a
for the chapel of the Madonna of Atocha in Madrid in the first decade of the 17th century.*

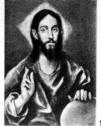

103A

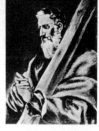

103B

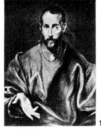

103C

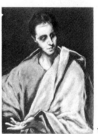

103D

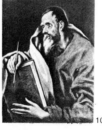

103E

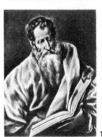

103F

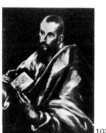

103G

103H

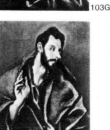

103I

104A

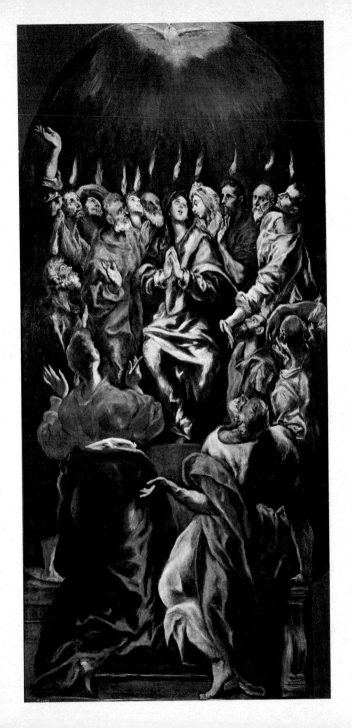

69

SAN FELIZ APOSTLES SERIES (Oviedo, Marqúes de San Feliz Collection) El Greco and Workshop

104A St Andrew
Oil on canvas/70 × 53/1600*

104B St Philip
Oil on canvas/70 × 53/s./1600*
Wrongly inscribed 'St Matthew'

104C St James Major
Oil on canvas/70 × 53/s./1600*

104D St James Minor
Oil on canvas/70 × 53/s./1600*

104E St John the Evangelist
Oil on canvas/70 × 53/1600*

104F St Judas Thaddaeus
Oil on canvas/70 × 53/1600*

104G St Luke
Oil on canvas/70 × 53/1600*
Wrongly inscribed 'St Simon'

104g idem
Oil on canvas/71 × 53.5/s./1600–10
New York, Hispanic Society
Replica of No. 104G

104H St Matthew
Oil on canvas/70 × 53/1600*
Wrongly inscribed 'St Philip'

104I St Paul
Oil on canvas/70 × 53/s./1600*

104i idem
Oil on canvas/37 × 28/
Formerly in New York, J. Levy Galleries
Replica of No. 104I. Pendant to No. 104l

104J St Peter
Oil on canvas/70 × 53/1600*

104K St Simon
Oil on canvas/70 × 53/1600*
Wrongly inscribed 'St Bartholomew'

The Crucifixion with a View of Toledo (No. 131).
The figure of Christ in this painting, which belongs to the artist's late maturity, has upturned face and elongated body; in the background is a view of Toledo by night. The theme of the suffering Christ is also seen in the painting in the Louvre (cf. No. 48).

104B

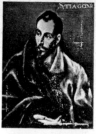
104C

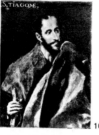
104D

104E

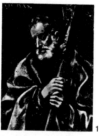
104F

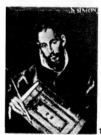
104G

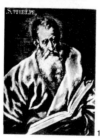
104H

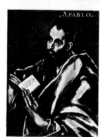
104I

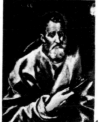
104J

104K

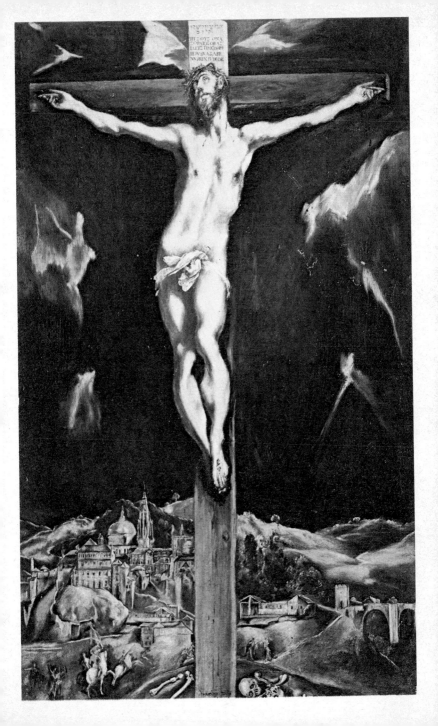

104L St Thomas
Oil on canvas/70 × 53/s./
1600*
104i idem
Oil on canvas/37 × 28/
Formerly in New York.
J. Levy Galleries
Replica of No. 104L. Pendant
to No. 104i

105a St John the Baptist
Oil on canvas/111 × 66/s./
1600–5*
San Francisco, M. H. de
Young Memorial Museum
105b idem
Oil on canvas/105 × 64/s.
Valencia, Museo Provincial
de Bellas Artes
Replica of No. 105a with
variations in the landscape

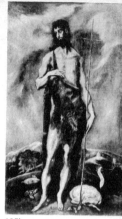

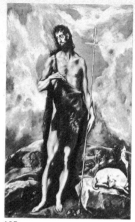

105a 105b

106a View of Toledo
Oil on canvas/121 × 109/s./
1595–1610
New York, Metropolitan
Museum (Havemeyer)
106b Landscape near Toledo
Oil on canvas/37 × 17/1600?
New York, J. Hirsch
Collection
Attribution

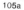

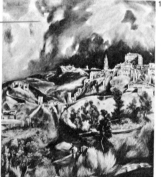

106a

107

**107 St Francis standing in
Meditation**
Oil on canvas/105 × 87/
1600–5
Madrid, Marqués de Santa
María de Silvela y de
Castañar Collection
Pendant to No. 93b

**108 St John the Evangelist
and St Francis**
Oil on canvas/64 × 50/
1600–5?
Madrid, Prado
Attribution

109 St Sebastian
Oil on canvas/89 × 68/*1600*
New York Art Market (1977)

108

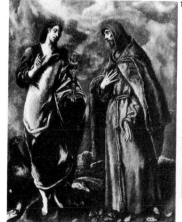

109

*The Agony in the Garden
(No. 136a).*
*The critics regard this as one
of the finest versions of the
theme by El Greco's own hand.
Various replicas and copies
are known. The canvas shown
here can be dated to the first
decade of the 17th century.*

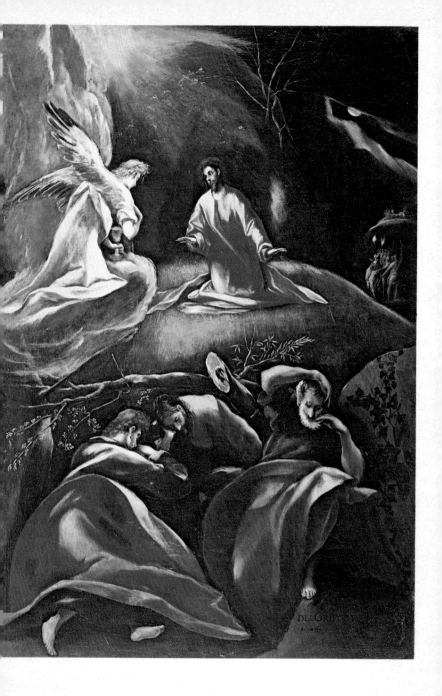

110 St Bernardino
Oil on canvas/269 × 144/s./
1603
Toledo, Museo del Greco

***PAINTINGS IN THE
CHURCH OF THE
HOSPITAL OF CHARITY
AT ILLESCAS***
*111A The Madonna of
Charity*
Oil on canvas/180 × 124/
1603–5
*111B The Coronation of the
Virgin*
Oil on canvas/163 × 220/
1603–5
111b idem
Oil on canvas/157 × 74/
Chicago, Epstein Collection
Probably a study for
No. 111B
111C The Annunciation
Oil on canvas/diam. 128/s./
1603–5
111D The Nativity
Oil on canvas/diam. 128/s./
1603–5
A preparatory study is
mentioned in Inventory I of
El Greco's possessions
111E St Ildefonso
Oil on canvas/187 × 102/s./
1600–5

112a The Annunciation
Oil on canvas/128 × 84/
*1600–5
Toledo (Ohio), Museum of
Art
112b idem
Oil on canvas/91 × 66.5/s./
1600–10
Budapest, Szépművészeti
Múzeum
112c idem
Oil on canvas/100 × 68/
Havana, Cintas Collection
112d idem
Oil on canvas/109 × 80/
Kurashiki (Japan), Soichiro
Ohara Collection
112e idem
Oil on canvas/107 × 74/
Sao Paulo (Brazil), Museum
of Art
Attribution

*113a Crucifixion with the
Madonna and St John the
Evangelist*
Oil on canvas/158 × 97/s./
1600–5
Sarasota (Florida), Ringling
Museum

74

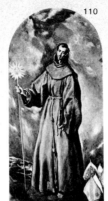

110

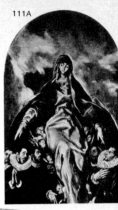

111A

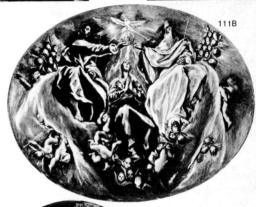

111B

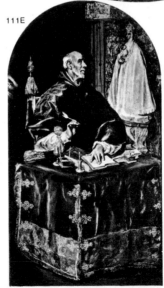

111E

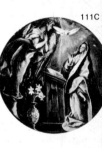

111C

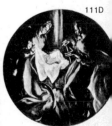

111D

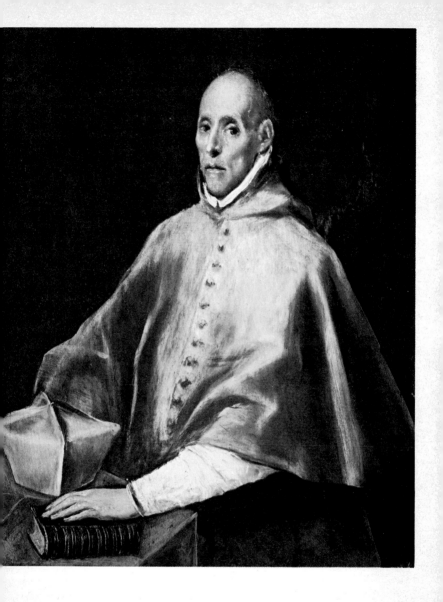

Portrait of Cardinal Juan de Tavera (No. 140).
El Greco probably painted the portrait in about 1608, using the Cardinal's death mask as a model (he had died in 1545). Juan de Tavera was the founder of the Toledo hospital for which El Greco created his last cycle of works.

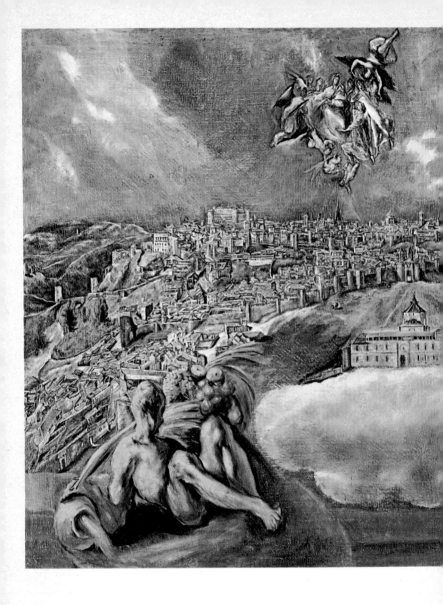

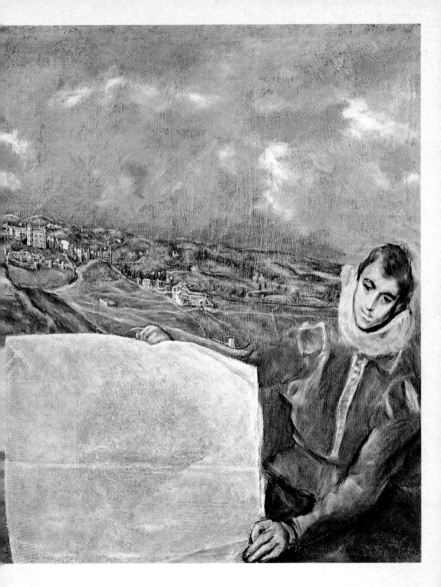

***View and Plan of Toledo
(No. 143).***
*The young man on the right,
generally identified as the
artist's son, Jorge Manuel, is
holding up a map with a long
inscription which explains the
iconography adopted in the
view, where the Tavera
Hospital appears in particular
prominence.*

113b idem
Oil on canvas/158 × 97/
1600–5
Philadelphia, John J. Johnson
Collection

114a The Vision of St Francis
Oil on canvas/203 × 125/s./
1600–5
Cádiz, Hospital de Nuestra
Señora del Carmen
114b idem
Oil on canvas/193 × 148/s.
Madrid, Museo Cerralbo
El Greco and workshop
114c idem
Oil on canvas/101 × 66/1610*
Madrid, Duques de
T'Serclaes Collection
Attribution

115 St Luke
Oil on canvas/s./1600–5
Rosario (Argentina), Museo
Municipal de Bellas Artes

**APOSTLE SERIES IN
TOLEDO CATHEDRAL
(SACRISTY)**
116A The Saviour
Oil on canvas/100 × 76/
1602–5
116B St Andrew
Oil on canvas/100 × 76/
1602–5
116C St Philip
Oil on canvas/100 × 76/
1602–5
El Greco and workshop
116D St James Major
Oil on canvas/100 × 76/
1602–5
116E St James Minor
Oil on canvas/100 × 76/
El Greco and workshop
116F St John the Evangelist
Oil on canvas/100 × 76/
1602–5
116G St Judas Thaddaeus
Oil on canvas/100 × 76/
1602–5
With some contributions by
the workshop
116H St Luke
Oil on canvas/100 × 76/
1602–5
May be a self-portrait
116I St Matthew
Oil on canvas/100 × 76/
1602–5
116J St Paul
Oil on canvas/100 × 76/
1602–5

112a

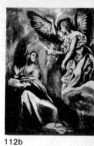

112b

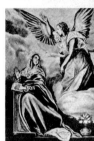

112c

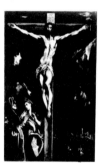

113a

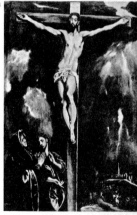

113b

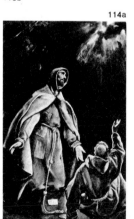

114a

115

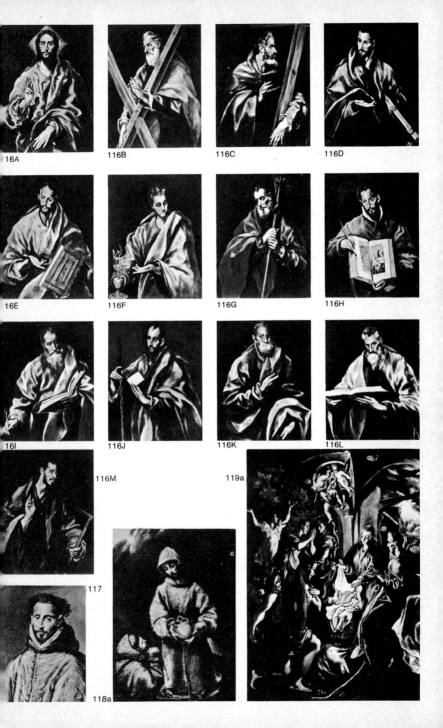

16A

116B

116C

116D

16E

116F

116G

116H

16I

116J

116K

116L

116M

119a

117

118a

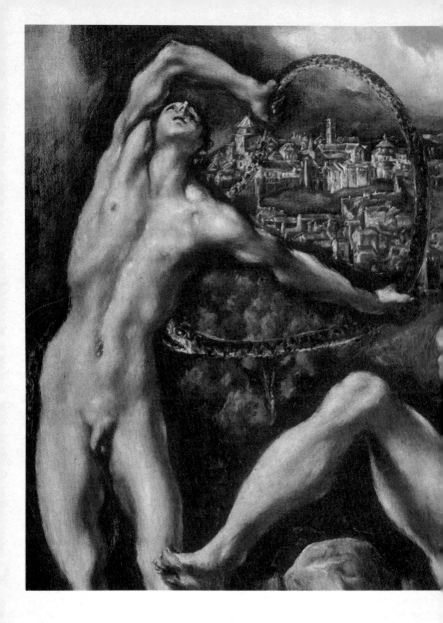

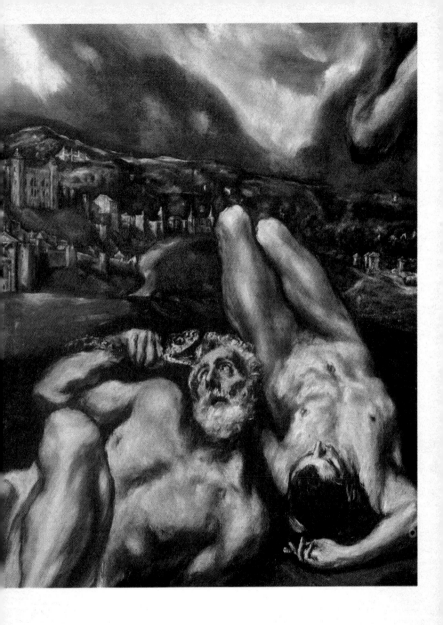

The Laocoön (No. 145; detail).
The mythical theme was widely used by 16th-century artists after the discovery in Rome of the Hellenistic sculptured group now in the Vatican museum. Here it is used in a very personal way, with a kind of furious dramatic tension, and is set against a background of Toledo.

116K St Peter
Oil on canvas/100 × 76/1602–5
Probably executed by the workshop
116L St Simon
Oil on canvas/100 × 76/1602–5
With contributions by the workshop
116M St Thomas
Oil on canvas/100 × 76/
With contributions by the workshop

117 Portrait of a Cardinal (St Bonaventure?)
Oil on canvas/57 × 46/1600–5
Melbourne, Gallery of Victoria
Greatly cut down from original dimensions (103 × 84)

118a St Francis and Brother Leo meditating on Death
Oil on canvas/168 × 103/s./1600–6
Ottawa, National Gallery of Canada
118b idem
Oil on canvas/155 × 100/s./1600–6
Sale, Sotheby's (1 November 1978)
118c idem
Oil on canvas/152 × 113/s./1585–95
Madrid, Prado
118d idem
Oil on canvas/112 × 80/s.
Merion (Pennsylvania), Barnes Foundation
118e idem
Oil on canvas/72 × 49/s./1590–5
Formerly in New York, Drey Collection
118f idem
Oil on canvas/102 × 65/
Toledo, Museo del Greco
Attribution
118g idem
Oil on canvas/109 × 67/s.
Milan, Brera
Attribution

119a The Adoration of the Shepherds
Oil on canvas/141 × 111/*1605
Valencia, Colegio del Patriarca
119b idem
Oil on canvas/164 × 107/1605–14
New York, Metropolitan Museum

120

121a

122

123

124

126a

125

127

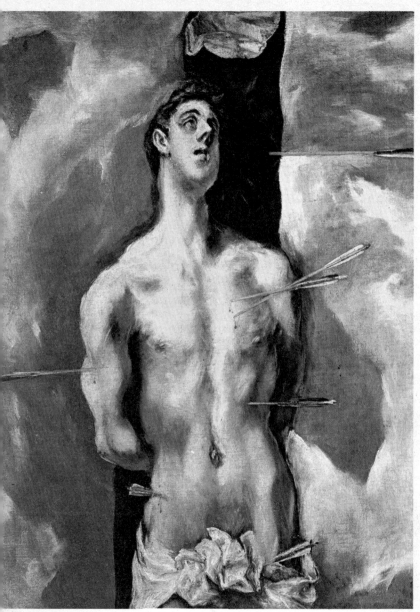

Sebastian (No. 148).
... late, emotional example of El Greco's use of ... is traditional religious subject. In the ... ckground is a view of Toledo. A fragment ... owing the lower part of the saint's figure has ... en discovered in recent years (see illustration ... the catalogue).

The Purging of the Temple (No. 149; detail).
(p. 85)
The last version of a theme which the artist used several times at different stages of his career. In the last period he accentuated the vertical quality of the composition and the serpentine movement of the figures.

120 St Dominic in Prayer
Oil on canvas/101 × 55/*1606
Toledo, Museo de Santa Cruz

121a St Peter and St Paul
Oil on canvas/123 × 92/
1605–8
Stockholm, Nationalmuseum
121b idem
Oil on canvas/121 × 105/
Leningrad, Hermitage

**122 Portrait of a Young
Gentleman**
Oil on canvas/55 × 49/s./
1600–10
Madrid, Prado

123 Portrait of a Gentleman
Oil on canvas/64 × 51/s./
1600–10
Madrid, Prado

124 Portrait of Canon Bosio
Oil on canvas/116 × 86/
1600–10
Kimbell Art Foundation,
Fort Worth

**125 Portrait of a Dominican
Monk (Trinitarian Monk [?])**
Oil on canvas/35 × 26/
Madrid, Prado

**126a Apparition of the Virgin
and Child to St Hyacinth**
Oil on canvas/158 × 98/
1600–10
Merion (Pennsylvania),
Barnes Foundation
126b idem
Oil on canvas/99 × 61/
1600–10
Rochester (New York),
Memorial Art Gallery

127 St Peter
Oil on canvas/207 × 105/
1605–10
Escorial, Monastery
Top of the canvas has been
cut down

128 St Ildefonso
Oil on canvas/222 × 105/
1605–10
Escorial, Monastery
Slightly cut at the top

129a The Resurrection
Oil on canvas/275 × 127/s./
1605–10
Madrid, Prado
Probably a pendant to
No. 130

129b idem
Oil on canvas/113 × 53/
Saint Louis (Missouri), City
Art Museum

128

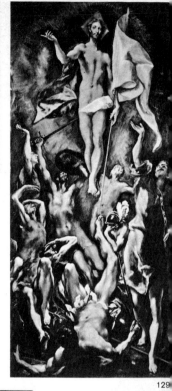

129

130

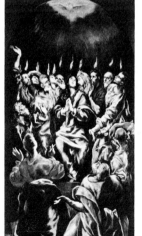

13

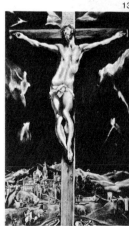

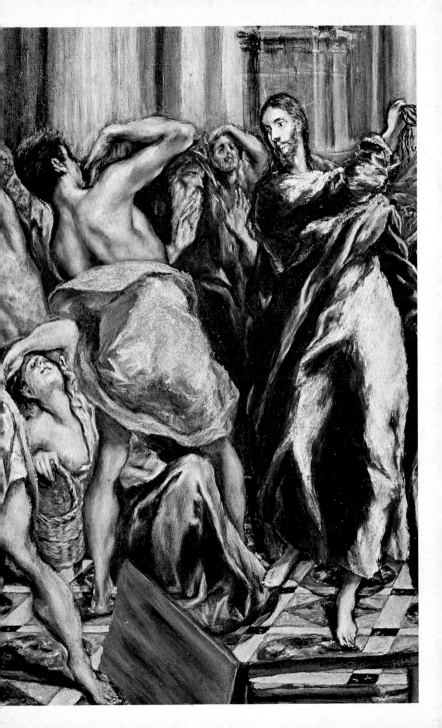

130 Pentecost
Oil on canvas/275 × 127/s./
*1605–10
Madrid, Prado
Probably a pendant to
No. 129a

131 Crucifixion with a View of Toledo
Oil on canvas/111 × 69/s./
1605–10
Madrid, Banco Urquijo

132 St Peter
Oil on canvas/71 × 55/
1605–10*
San Francisco, California
Palace of the Legion of
Honor
El Greco and workshop.
Pendant to No. 571

132

133 St John the Evangelist and St John the Baptist
Oil on canvas/110 × 87/
1605–10
Toledo, Museo de Santa Cruz

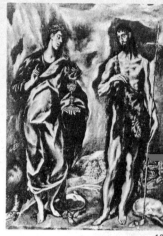

13

134 St Mary Magdalene in Penitence
Oil on canvas/118 × 105/s./
1605–10
Bilbao. F. Valdés Izaguirre
Collection

135

135 Madonna Nursing the Christ Child
Oil on canvas/90 × 71/
1605–10
Madrid, Marquésa de Campo
Real Collection

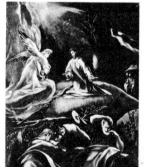

134

136a The Agony in the Garden
Oil on canvas/169 × 112/s./
1605–10
Andújar (Jaén), Church of
Santa Maria
136b idem
Oil on canvas/170 × 112.5/s./
*1605–10
Budapest, Szépmüvészeti
Muzeum
136c idem
Oil on canvas/110 × 76/
1605–14
Buenos Aires, Museo
Nacional de Bellas Artes

136a

136b

The Adoration of the Shepherds (No. 151a).
Among the most important works of the artist's last period, this was probably intended for his family burial vault in the church of Santo Domingo el Antiguo in Toledo.

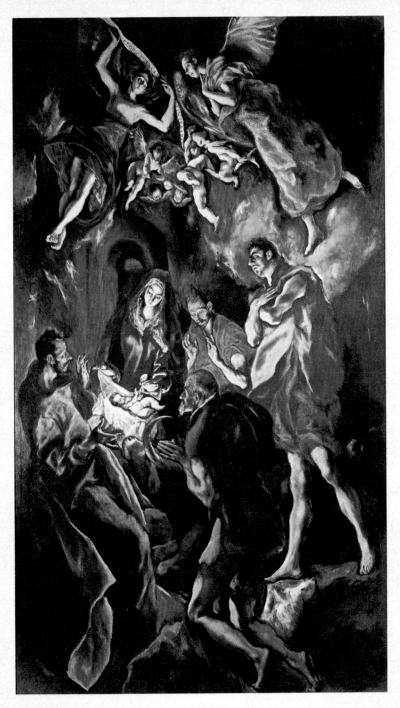

137 The Immaculate Conception
Oil on canvas/108 × 82/
1605–10
Lugano, Thyssen Collection

138 Portrait of Fray Hortensio Félix Paravicino
Oil on canvas/113 × 86/s./
1609
Boston, Museum of Fine Arts

139 Portrait of Jerónimo de Cevallos
Oil on canvas/65 × 54/
1605–14
Madrid, Prado

140 Portrait of Cardinal Juan de Tavera
Oil on canvas/103 × 82/
1608–14
Toledo, Tavera Hospital

141a Christ in the House of Simon
Oil on canvas/143 × 100/
1605–14
Chicago, Art Institute
Possibly with the
participation of Jorge Manuel
141b idem
Oil on canvas/150 × 104/
1605–14
New York, Brooklyn
Museum (Cintas)
El Greco and workshop

PAINTINGS FOR THE CAPILLA OBALLE IN SAN VICENTE, TOLEDO
142A The Immaculate Conception
Oil on canvas/347 × 154/
1607–13
Toledo, Museo de Santa Cruz
142B The Visitation
Oil on canvas/97 × 71/
1607–14
Washington, Dumbarton
Oaks Research Library and
Collection

The Adoration of the Shepherds (No. 151a; detail with St Joseph).
In this transfiguring interpretation of the story from the Scriptures, St Joseph is shown as a younger man than usual, with his hands raised in wonder and adoration.

138

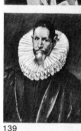

137

139

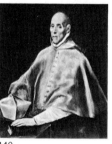
140

141a

142A
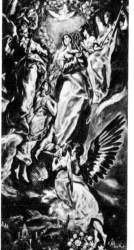

142B
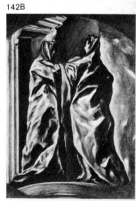

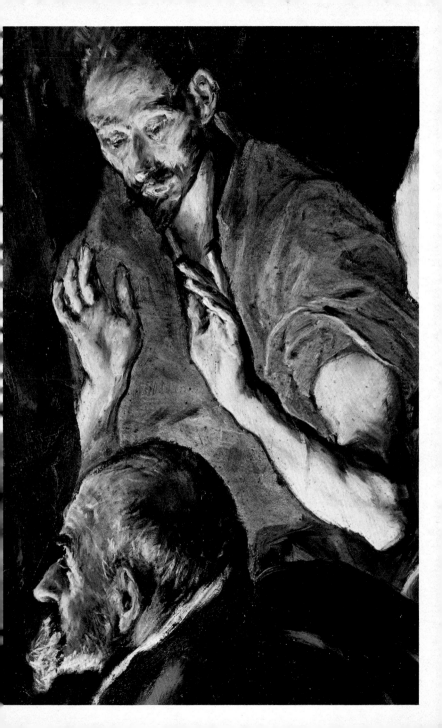

143 View and Plan of Toledo
Oil on canvas/132 × 228/
1608–14
Toledo, Museo del Greco

**APOSTLE SERIES,
MUSEO DEL GRECO,
TOLEDO**
144A The Saviour
Oil on canvas/97 × 77/
1610–14
144B St Andrew
Oil on canvas/97 × 77/
*1610–14
Beard and hand unfinished
144C St Bartholomew
Oil on canvas/97 × 77/
1610–14
144D St Philip
Oil on canvas/97 × 77/
1610–14
Unfinished areas in the face
144E St James Major
Oil on canvas/97 × 77/
1610–14
Left hand unfinished
144F St James Minor
Oil on canvas/97 × 77/
1610–14
144G St John the Evangelist
Oil on canvas/97 × 77/
1610–14
El Greco and workshop
144H St Judas Thaddaeus
Oil on canvas/97 × 77/
1610–14
Unfinished
144I St Matthew
Oil on canvas/97 × 77/
1610–14
144J St Paul
Oil on canvas/97 × 77/s./
1610–14
144K St Peter
Oil on canvas/97 × 77/
1610–14
144L St Simon
Oil on canvas/97 × 77/
1610–14
144M St Thomas
Oil on canvas/97 × 77/
1610–14

**The Baptism of Christ
(No. 153A).**
*This belongs to the last series
of paintings made for the
Tavera Hospital in Toledo
which were largely unfinished
when the artist died. Along the
left-hand margin some colour
tests are visible.*

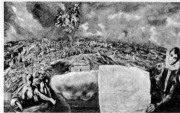
143

144A

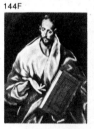
144B

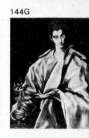
144C

144D

144E

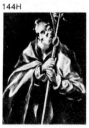
144F

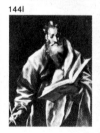
144G

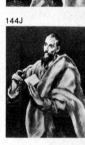
144H

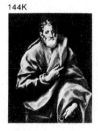
144I

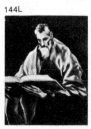
144J

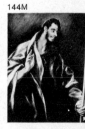
144K

144L

144M

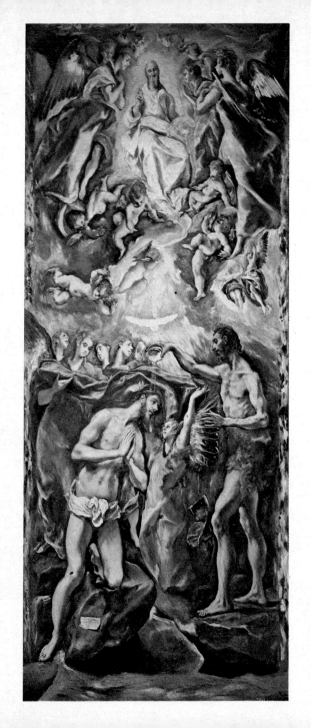

145 Laocoön
Oil on canvas/142 × 193/
1610–14
Washington, National
Gallery of Art (Kress)
Has some unfinished areas

146a St Catherine of Alexandria
Oil on canvas/90 × 61/s./
1610–14
Topsfield (Mass.), Coolidge
Collection
146b idem
Oil on canvas/57 × 48/s.
Formerly New York,
Metropolitan Museum of Art

147 The Annunciation
Oil on canvas/152 × 99/
1610–14
Sigüenza, Cathedral, Chapter
House

148 St Sebastian
Oil on canvas/115 × 85/
1610–14
Madrid, Prado. The fragment
with the saint's legs and
landscape (oil on canvas) is in
Madrid, Arenaza Collection

149 The Purging of the Temple
Oil on canvas/106 × 104/
*1610–14
Madrid, Church of San Ginés
(Cofradia del Santísimo
Sacramento)
El Greco and Jorge Manuel

150 St Jerome in Penitence
Oil on canvas/168 × 110/
1612–14
Washington, National
Gallery of Art (Chester Dale)

The Annunciation (No. 153B).
*This is part of the series made
for the Tavera Hospital in
Toledo. The upper part of the
painting, showing an* Angel
Concert, *has been recognized
in a fragment preserved in the
National Gallery of Athens.*

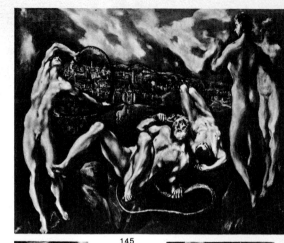

145

146a

147

149

148

150

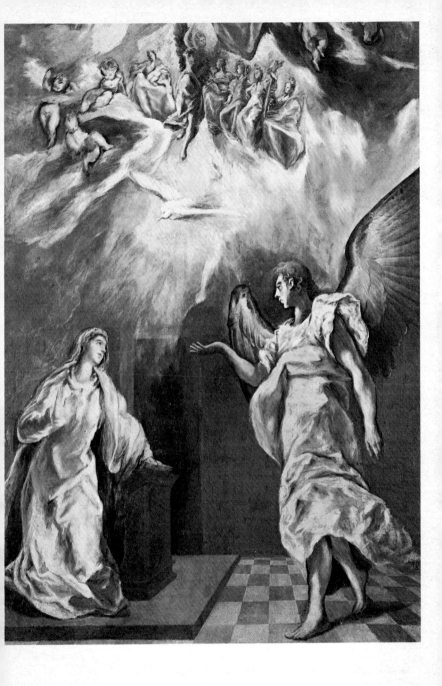

151a The Adoration of the Shepherds
Oil on canvas/320 × 180/
1612–14
Madrid, Prado
151b idem
Oil on canvas/111 × 65/
1600–14
New York, Metropolitan
Museum

152 The Marriage of the Virgin
Oil on canvas/110 × 83/
1613–14
Bucharest, Romanian
National Museum
Unfinished, and probably cut
down in recent years

WORKS FOR THE TAVERA HOSPITAL, TOLEDO
153A The Baptism of Christ
Oil on canvas/330 × 211/
1608–14
Toledo, Tavera Hospital
El Greco and Jorge Manuel
153B The Annunciation
Oil on canvas/291 × 205/
1608–14*
Madrid, Banco Urquijo
The upper fragment with an
Angel Concert (oil on canvas/
112 × 205) is in the National
Gallery in Athens
Unfinished, and probably cut
down in the late 19th century
153C The Opening of the Fifth Seal in the Book of Revelations
Oil on canvas/225 × 193/
1608–14*
New York, Metropolitan
Museum
The upper part of the canvas
was probably destroyed

151a

152

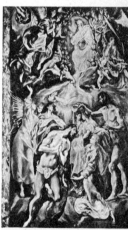
153A

153B

153C

Photocredit
All the photographs of the
paintings are from the Rizzoli
Photoarchive.

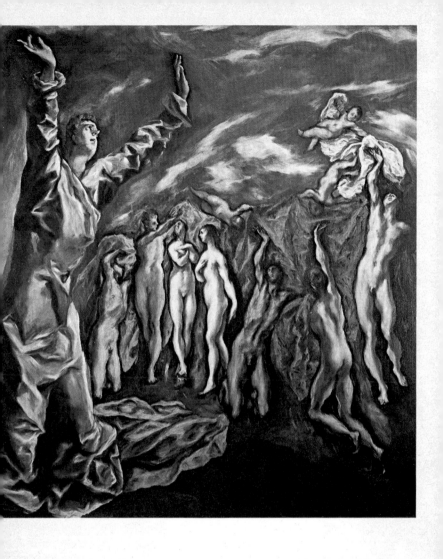

The Opening of the Fifth Seal in the Book of Revelations (*No. 153C*).
Generally regarded by scholars as part of the cycle of paintings for the Tavera Hospital, this interpretation of a passage from the Revelation of St John has an astonishing supernatural quality.

Bibliography

Sources and documents: F. DE PISA, *Descripción de la imperial ciudad de Toledo*. . . , Toledo 1605, 2nd edn 1617. G. MANCINI, *Alcune considerazioni appartenenti alla pittura, c.*1620 (ed. A. Marucchi and L. Salerno), Rome 1956. F. PACHECO, *Arte de la pintura*, Seville 1649 (ed. F. J. Sanchez Canton, 1956). A. PALOMINO, *El Museo pictórico y Escala óptica*, Madrid 1715–16. J. A. CEÁN BERMÚDEZ, *Diccionario histórico*. . . , Madrid 1800. F. BORJA DE SAN ROMAN Y FERNANDEZ, *El Greco en Toledo*, Madrid 1910. 'De la vida del Greco', in *Archivio español de arte y arqueología* [abbreviated to *AE*; see list of abbreviations below], 1927. F. J. SANCHEZ CANTÒN, *Fuentes literarias*. . . , v.II–V, Madrid 1933–41. M. R. ZARCO DEL VALLE, *Datos documentales para la historia del arte español. Documentos de la Catedral de Toledo*, Madrid 1916. N. COSSIO DE JIMÉNEZ, *El Greco. Notes on his Birthplace, Education and Family*, Oxford 1948. C. D. MERTZIOS, 'D. Theotocopoulos: nouveaux éléments biographiques', in *AV*, 1961.

Modern studies: K. JUSTI, 'Die Anfänge des Greco', in *ZBK*, 1897. S. VINIEGRA, *Catalogo della mostra del Greco al Prado*, Madrid 1902. M. B. COSSIO, *El Greco*, Madrid 1908 and *D. Theotocopuli*, Oxford 1957 (ed. N. Cossio de Jiménez). M. BARRÈS, *Greco ou le secret de Tolède*, Paris 1910. J. MEIER-GRAEFE, *El Greco*, Munich 1911. H. KEHRER, *Die Kunst des Greco*, Munich 1914. M. DVORÁK, 'Kunstgeschichte als Geistesgeschichte (Uber Greco und den Manierismus)', in *JK*, 1921. E. DU GUÉ TRAPIER, *El Greco*, New York 1925; *El Greco's Early Years at Toledo*, New York 1958; 'El Greco in the Farnese Palace', in *GBA*, 1958. A. L. MAYER, 'Dominico Theotocopuli El Greco', in *BM*, 1939. J. F. WILLUMSEN, *La jeunesse du Greco*, Paris 1927. F. ANTAL, 'Zum Problem des niederländischen Manierismus', in *KB*, 1928–9. R. BYRON, 'Greco: The Epilogue to Byzantine Culture', in *BM*, 1929. P. A. SCHWEINFURTH, 'Greco und die italokretische Schule', in *BZ*, 1930. J. CASSOU, *Le Greco*, Paris 1931. A. M. BRIZIO, 'Il Greco a Venezia', in *AR*, 1932. S. BETTINI, *La pittura di icone cretese-veneziana e i madonneri*, Padua 1933; 'Precisazioni sull'età giovanile del Greco', in *AV*, 1952. R. PALLUCCHINI, *Il polittico del Greco nella R. Galleria Estense*, Rome 1937; G. MARTIN-MERY, *Catalogo della Mostra 'Le Greco de la Crète a Tolède par Venise'*, Bordeaux 1953; *Il Greco*, Milan 1956; 'Contributi alla pittura veneta del Cinquecento', in *AV*, 1959–60; *Il Greco a Venezia*, 1966. R. TALBOT RICE, 'El Greco and Byzantium', in *BM*, 1937. M. LEGENDRE–A. HARTMANN, *El Greco*, Paris 1938. L. GOLDSCHEIDER, *El Greco*, New York 1938 and 1954. A. BLUNT, 'El Greco's Dream of Philip II', in *JWC*, 1935–40. X. DE SALAS, 'La valoracion del Greco. . .', in *AR*, 1941. J. CAMON AZNAR, *Dominico Greco*, Madrid 1950 (with extensive bibliography). M.

CHATZIDAKIS, 'D. Theotocopulos e la cultura cretese' (in Greek), in *KC*, 1950. L. BRONSTEIN, *El Greco*, New York 1951. A. P. PROCOPIOU, 'El Greco and Cretan Paintings', in *BM*, 1952. A. VALLENTIN, *El Greco*, Paris 1954. M. S. SORIA, 'Greco's Italian Period', in *AV*, 1954; 'Algunos pintores madoneros ecianos', in *Goya*, 1960. P. GUINARD, *Greco*, Geneva 1959. H. SÖHNER, 'Der Stand der Greco', in *ZK*, 1956 (with updated bibliography); 'Greco in Spanien', in *MJK*, 1957, 1958, 1959, 1960. M. FLORISOGNE, 'La mystique plastique du Greco . . .', in *GBA*, 1957. R. WITTKOWER, 'El Greco's Language of Gestures', in *ANK*, 1957. E. ARSLAN, 'El Greco', *Enciclopedia Universale dell'Arte*, VI, 1958; 'Cronistoria del Greco madonnero', in *C*, 1964. K. IPSER, *El Greco*, Berlin 1960. P. KÉLEMEN, *El Greco revisited*. . . , New York 1961. F. J. SANCHEZ CANTÓN, *El Greco*, Milan 1961, L. PUPPI, 'Il Greco giovane . . .', in *PR*, 1962; *El Greco*, Florence 1967. H. E. WETHEY, *El Greco and his school*, Princeton 1962 (with complete catalogue), R. LONGHI, 'Una monografia su El Greco', in *P*, 1963. P. TROUTMAN, *El Greco*, London-Verona 1963, 1967. W. PALM ERWIN, 'El Greco's Laocoön', in *PT*, 1969. E. LAFUENTE FERRARI–J. M. PITA ANDRADE, *Il Greco di Toledo e il suo espressionismo estremo*, Milan 1969. J. GUDIOL, *Le Greco*, Paris 1973. J. LASSAIGNE, *El Greco*, Paris 1973. D. DAVIES, *El Greco*, Phaidon, 1976.

List of abbreviations

AE	*Archivio español de arte y arqueología*
ANK	*Alte und neue Kunst*
AR	*L'Arte*
AV	*Arte veneta*
BM	*The Burlington Magazine*
BZ	*Byzantinische Zeitschrift*
C	*Commentari*
GBA	*Gazette des Beaux-Arts*
JK	*Jahrbuch für Kunstgeschichte*
JWC	*Journal of the Warburg and Courtauld Institutes*
KB	*Kritische Berichte*
KC	*Kretika chronika*
MJK	*München Jahrbuch der bildende Kunst*
P	*Paragone*
PR	*Prospettive*
PT	*Pantheon*
ZBK	*Zeitschrift für bildende Kunst*
ZK	*Zeitschrift für Kunstgeschichte*

First published in the United States of America 1980 by Rizzoli International Publications, Inc. 712 Fifth Avenue, New York, New York 10019 Copyright © Rizzoli Editore 1979 This translation copyright © Granada Publishing 1980 Introduction copyright © Sir Ellis Waterhouse 1980 ISBN 0-8478-0265-5 LC 79-64901 Printed in Italy